IMAGES
of America

BEDFORD AND
BEDFORD TOWNSHIP

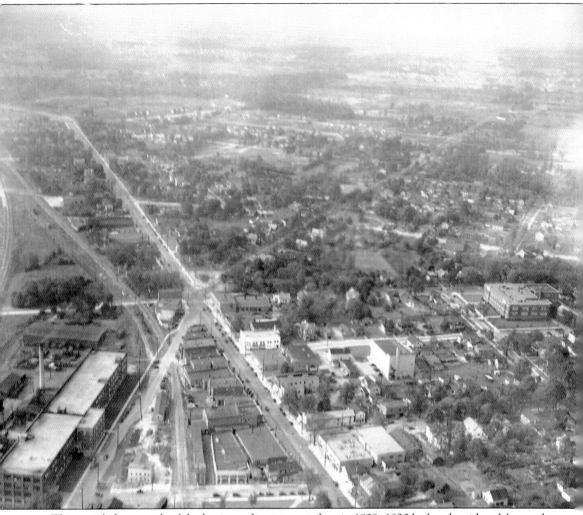

This aerial photograph of the business district was taken in 1929–1930 by local resident Maynard Gauldin of the Ohio National Guard. (Courtesy of the Bedford Historical Society.)

ON THE COVER: Milan Duris stands at the corner of Warrensville Center Road near Broadway for this photograph of Broadway looking southeast. Duris had a 33-year career in the Bedford Police Department, including 11 years as chief. He loved photography and captured many images of the area, including this photograph taken in the early 1950s. (Courtesy of Alvin Silbaugh.)

IMAGES of America
BEDFORD AND BEDFORD TOWNSHIP

Janet Caldwell for the
Bedford Historical Society

ARCADIA
PUBLISHING

Copyright © 2012 by Janet Caldwell for the Bedford Historical Society
ISBN 978-0-7385-9369-2

Published by Arcadia Publishing
Charleston, South Carolina

Printed in the United States of America

Library of Congress Control Number: 2012933932

For all general information, please contact Arcadia Publishing:
Telephone 843-853-2070
Fax 843-853-0044
E-mail sales@arcadiapublishing.com
For customer service and orders:
Toll-Free 1-888-313-2665

Visit us on the Internet at www.arcadiapublishing.com

*This book is dedicated to the people from our township communities
who offered the use of photographs, supplied information,
and shared their stories; these are the "history keepers."*

Contents

Acknowledgments		6
Introduction		7
1.	Every Piece in Them is Perfect	9
2.	Our Best Services	25
3.	Rent Money Wasted, Own Your Own Home	47
4.	Equal to Any and Excelled by None	71
5.	The Little Church with the Big Heart	83
6.	Yourself and Lady Are Cordially Invited	93
7.	Always a Good Show	107
8.	New Route Open	115
Index		127

ACKNOWLEDGMENTS

This pictorial timeline provides a glimpse into the unique history of Bedford, Ohio, and surrounding Bedford Township communities. The images represent a span of almost 200 years. The majority of photographs and maps used in this book are from the archives of the Bedford Historical Society. These represent over 50 years of donations from people who saw the value of preserving history. Additional photographs are marked with the names of donors. Thank you for sharing these images.

 The author owes a debt of gratitude to the staff and volunteers of the Bedford Historical Society. Joyce Maruna, Paul Pojman, Helen Pratt, Lynn Jones, Diane Balach, and Deborah Grubb helped research, select images, or proofread text. Cathie O'Neill supplied additional proofreading. John Straka and Jean Kainsinger helped review historic content. Helen Batko created the index. Special thanks to Helen Pratt, who scanned the images used in the book plus three times as many, which were not chosen.

 Founded in 1955, the Bedford Historical Society collects and records the history of this region. It presents programs and exhibits to educate others about life in this area. This book helps tell the story of how we developed.

INTRODUCTION

Bedford and its neighboring communities of Walton Hills, Bedford Heights, Oakwood Village, and Maple Heights are all communities of old Bedford Township in Cuyahoga County, Ohio. As each area developed enough population and resources to become independent, the township diminished and then ceased to exist in 1951. All of the residents in these communities share a common heritage of early life in the Western Reserve where pioneers settled to make a better life for themselves. New residents move here for the same opportunities.

Bedford Township was surveyed on the second expedition of Moses Cleaveland to the area in 1797. General Cleaveland was hired by the Connecticut Land Company to survey and mark rangelands and smaller areas known as townships. Townships in the Western Reserve Lands contain about 25 square miles. When surveyors Seth Pease and Amzi Atwater helped survey Range 11 Township 6, they labeled it, "Well watered and plenty of mill seats." They entered into their journal that it was a "most excellent township."

Settlers began to arrive as early as 1813 to the yet unnamed Township 6. The "most excellent" township had an abundance of natural resources. The lands east of the Cuyahoga, including Township 6, are part of the Appalachian range with an abundance of hardwood in dense forests. The "well watered" township offered plenty of locations to dam water for use as mill sites. One of the most promising sites was the large elevation drop along Tinkers Creek in the center of the township. This area became central to the life of the township.

The township officially organized in 1823. Daniel Benedict, who operated a sawmill on Tinkers Creek, suggested Bedford as a name for Township 6. He was originally from Bedford, Connecticut, which became Bedford, New York, as the result of a land dispute between those states.

By 1837, most of the 475 residents lived near the center of the township around Lot 46. The mills at the end of Willis Street served outlying rural areas. A small business district developed nearby along the Turnpike Road to serve travelers and local residents. Enterprising businessman Hezekiah Dunham and his family were some of these early settlers. Dunham had wealth and influence. He donated land for schools, churches, and a public square. This concentration of people and those who came daily to transact business required additional governance. The area surrounding Lot 46 became the village of Bedford. In 1932, the village reorganized to a city-manager form of government.

The third key to success for the village and its surrounding township neighbors was transportation. The Turnpike Road was the main trade route between Cleveland, a frontier town in the Western Reserve, and Pittsburgh, a well-established city known as the "Gateway to the West." This route was established well before roads connected the Western Reserve with other portions of the state and the new state capital. The Turnpike Road passed through the center of the township, and Bedford was a stagecoach stop along this route. A bit of luck was involved here. A team of horses pulling a load needed to take a break every 10 to 12 miles. In the case of stagecoaches, so did the passengers. The center of Bedford Township is roughly 10 to 12 miles from Cleveland

on the way to Pittsburgh. Liveries, hotels, and food service developed to cater to these travelers. This old route is still one of the busiest, known as State Route 14 in Ohio and State Route 51 in Pennsylvania. The Cleveland & Pittsburgh Railroad roughly followed the old stage route. Regions that were fortunate to have rail transportation thrived. Another important transportation form was light rail, which allowed people to travel between towns and cities along the trolley route. The nation's first high-speed, interurban light rail system, the ABC Line, connected Akron, Bedford, and Cleveland. With connecting trolleys, passengers could travel for hours throughout all of Northern Ohio. The village of Bedford had many liveries and blacksmiths to serve the horse trade. The area was surrounded by horse-racing tracks, including Cranwood, Thistledown, and the Maple Heights Jockey Club. As horses gave way to the automobile, the automobile industry established itself in the area. Today, Bedford has one of the largest concentrations of car dealerships and post-market automobile repair and parts suppliers. Automobile sales have spread into Maple Heights. Bedford Heights has one of the largest motorcycle dealerships in the country. Walton Hills has received the financial benefit of a Ford stamping plant within its borders.

Early industry in the township included chair manufacturing. Benjamin Fitch, considered the father of chair manufacturing in this area, brought his chair-making skills from New England. Fitch's reputation for solid, well-built chairs soon spread, and he required the services of apprentices to keep up with orders. Fitch, along with one of his apprentices, William Taylor, founded the W.O. Taylor Company, which remains in business today as the Taylor Company. Several other furniture manufacturers called the Bedford area home. By the start of the 20th century, area manufacturing included the McMyler Interstate Company that made the largest crane in the world—the Navy League Island crane in Philadelphia. The Walker China Company manufactured institutional china for restaurants, schools, hospitals, and the military. Ben Venue Laboratories was a pioneer in freeze-drying parenteral drugs.

Notable residents include Archibald Willard, painter of *The Spirit of '76*. Dr. Theodatus Garlick, a pioneer in the field of plastic surgery, also developed the science of artificial fish propagation, a technique still used by the fish farming industry today. Baseball Hall of Fame great Elmer Flick was born and lived in Bedford. Resident Mary Cowan was a nationally known criminologist. These are a few of the citizens who have contributed to the welfare of America.

Churches played an important role in the life of our township communities. The earliest settlers brought strong Protestant ethics. It was a major route along the Underground Railroad, and Bedford men served in the Civil War in record numbers. Immigrants brought Catholicism and established several churches that served the area. The region continues to expand with new churches while older ones have closed or merged.

Clubs and organizations offered residents an opportunity to socialize and serve the community. Residents and visitors have had a wide range of recreational activities, including golf, hiking, horseback riding, and bicycling. Entertainment over the years has included productions at the opera hall in the 1874 Town Hall, public recitals offered by the Bedford Music Club, Knights of Pythias productions, and movies at several theaters.

The village of Bedford and its rural neighbors of Bedford Township worked cooperatively to become very successful. As people continued to move to the region, the area in northwest Bedford Township became self-governing. The village of Maple Heights was founded in 1915. The last vestiges of old Bedford Township dissolved in 1951 when the villages of Bedford Heights, Walton Hills, and Oakwood became independent. Communities assumed responsibility for the roads within their boundaries. Bedford Public Square and Bedford Cemetery, both township lands, were deeded to the city of Bedford for maintenance. Schools in the Bedford Rural School District were incorporated into Bedford City School District or Maple Heights City School District.

Today, the areas of old Bedford Township have developed into communities with neighborhoods, industry, commerce, and places for recreation. A road system easily allows residents to work throughout Northeast Ohio. It has an abundance of natural beauty, much of which is protected by a large county park system with an adjacent national park. And it is blessed with people who add their own signature to help define the American Dream.

One
Every Piece in Them is Perfect

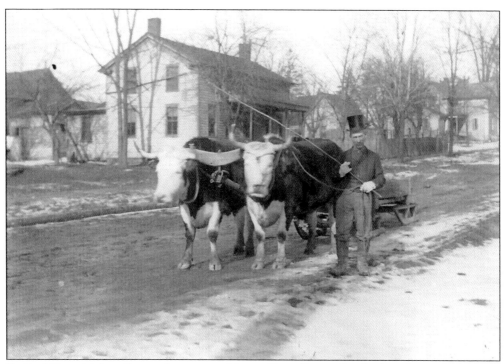

Bedford Township's earliest settlers operated farms. Here, George Rorabeck and oxen deliver milk along Columbus Road. The farm was in the eastern portion of the township. Ned Hubbell, a local author, wrote in his book *Life in Bedford 1813–1970* that "George Rorabeck and Otto Johnson drove about the village in their rigs ladling milk at five cents a quart from milk cans into pans held by their women customers."

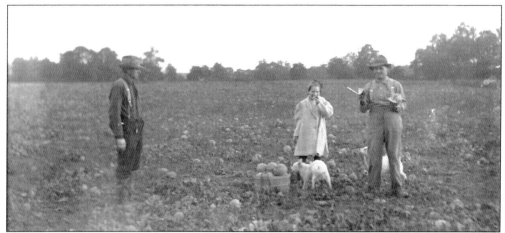

This 1909 photograph shows Charles Walter James (C.W.J.) Alexander and his daughter Mary sampling a muskmelon cut by hired hand Joe Durda. C.W.J. leased the farm from his relative Andrew Alexander, who also owned a mill along Canal Road. He and his brother were orphaned at a young age and taken in by a family who did not treat them well. At age 14, he ran away and eventually was cared for by relatives living in Nebraska. C.W.J. married Anna Jacobs from Illinois. They tried homesteading on the Nebraska plains; one year, crops were destroyed by locusts, followed by two years of drought. The failed venture was enough. He and his young family moved to Bedford Township.

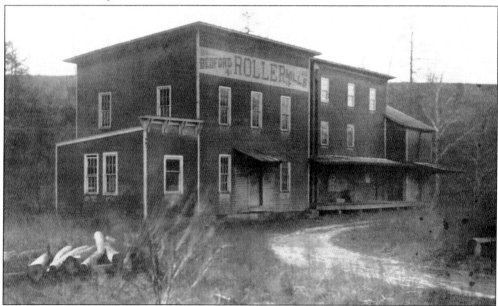

Adams and Starr built the first mill in 1815 near the mouth of Tinkers Creek. Luther Willis built a gristmill in 1825 at the Great Falls. The Gates family acquired the mill about 1872. The back of the photograph reads, "On Friday morning all the grocers went to Gates Mill to buy flour—Snowball (straight winter wheat); Pansy (10% spring wheat) and Young America (cheap type sold mainly to Italians for spaghetti and macaroni)." The mill ceased operation about 1908. In 1891, the People's Electric Light Company was constructed near Gate's mill. After the mills closed each evening, a sluice diverted water to the People's Electric Light Company. Bedford was one of the first villages to have electricity.

Benjamin Franklin Fitch, seen here, started the first chair company. By using a combination of "green," or unseasoned, wood and drier, seasoned wood, Fitch's chairs would tighten as they cured to lock the joints without glue or nails. Fitch hired apprentices to handle the increased demand. Apprentice William O. Taylor from nearby Summit County married Fitch's daughter. The two men founded the William O. Taylor Chair Company. In 1859, Taylor moved the company from Libby Road to the village of Bedford beside the new Cleveland & Pittsburgh Railroad track.

In 1870, rockers sold for $22 a dozen. Within days after the Great Chicago Fire, Taylor shipped boxcars of chairs to Chicago. Salesmen and innovative advertising kept workers busy. In 1885, average weekly production was 1,618 chairs. The company was an excellent example of the industrial revolution. Employees worked in modern buildings with many windows for daylight and electric lighting. A unique three-story outhouse could be accessed from each floor, saving time. The manufacturing of time-consuming caned or rush seats was outsourced to local homes where it was a cottage industry.

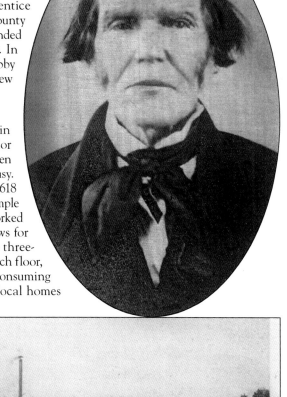

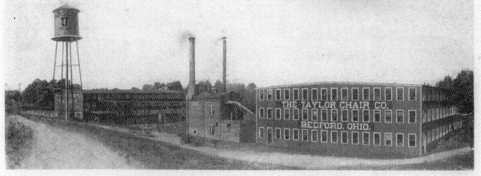

With factory wheels a humming
And great train loads a running
We stand before your door and shout for more;
And we'll never cease our knocking
Till the whole wide world is rocking,
And we find our Taylor Rockers on your floor.

General Offices
and Works
The Taylor Chair Co.

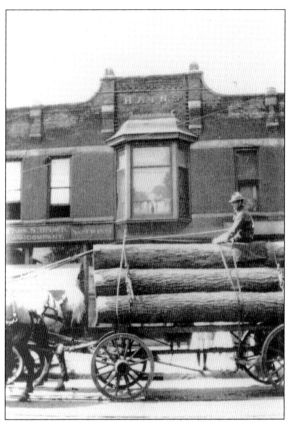

The wagon is passing the Hains building in the 600 block of Broadway in the late 1890s or early 1900s. Local woodlots furnished hardwoods, and the railroad delivered mahogany, a popular exotic import. Several other furniture manufacturers operated in the Bedford area. Barzilla L. Marble and Abner L. Shattuck founded the Marble and Shattuck Chair Company in 1885. A serious fire in 1886 resulted in the loss of the company's entire finished stock. After another fire in 1894, blamed on arson, the company moved to the Glenville area of Cleveland. It remained in business until the late 1930s or 1940s.

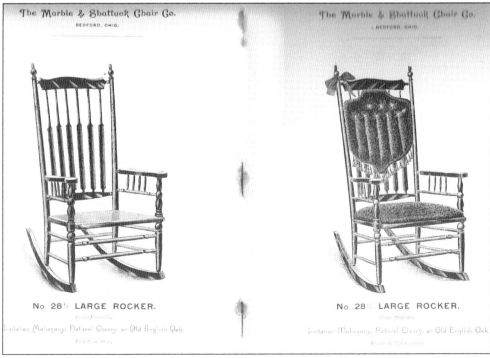

B.L. Marble started the B.L. Marble Chair Company in 1894. A three-story brick building opened in 1921 and remained the company headquarters until closing in 1985. The B.L. Marble Chair Company employed many local residents. A company logo that greeted workers in the plant read, "Every piece in them is perfect." Marble manufactured airplane propellers during World War I and made the propellers for the first transatlantic flights of the NC-1, NC-2, NC-3, and NC-4 in 1919.

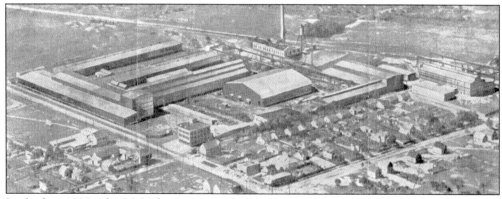

In the late 1890s, the McMyler Interstate Company, an engineering and iron foundry, built a 43-acre campus along Northfield Road beside the Pennsylvania Railroad tracks. The campus included a recreational building with bowling lanes and a pool room. It also had a hospital for employees and their families. Minor surgeries, such as tonsillectomies, were performed in the company hospital. The lithographic photograph is from a company promotional.

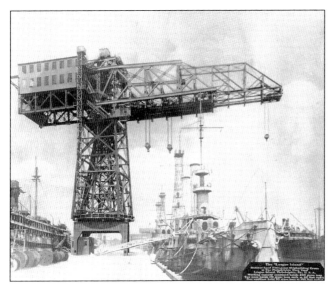

The company engineered and fabricated an extensive line of heavy-duty equipment, including steel trusses, cranes, and ore dumpers. In World War I, McMyler manufactured many items for the military, such as huge shipboard gun barrels. The League Island Crane, seen here at the Philadelphia Naval Shipyard, was one of the company's engineering marvels. The crane was used to lift gun turrets into position on shipboard. When the crane was dismantled about 1999, a piece of it was retained at the Naval Museum in Washington, DC.

The Eagle Avenue Bridge in Cleveland, Ohio, was manufactured by McMyler Interstate around 1931. The main office stood at the corner of Northfield Road and Interstate Street. From left to right, Gertrude Miller, Marjorie Walling, and Florence Webster pose with their supervisor Miss Dodds. In the 1930s, the massive plant ceased operation, and the facilities were placed for sale. By 1934, the Federal Emergency Relief Administration (FERA) used the McMyler plant for its Civil Works Administration (CWA) program. Several other companies have used the buildings built by McMyler over the years. (Courtesy of Doris Shriver.)

John Wardley was hired by William Holmes Bronze Company of Akron Ohio to find a location closer to Cleveland. Bedford proved to be the right place, along the west side of Main Street between Powers Road and West Grace Street next to the railroad. The William G. Holmes Bronze Company, seen here from the rear, began production in late 1911 or 1912. The company manufactured high-grade bronze, aluminum castings, brass fittings, and other industry supplies. Examples of its products include battery terminals and gears. The photograph was taken in 1922 when production was healthy. By 1938, the company ceased manufacturing, a victim of the Great Depression. The main building has served as several car dealerships. The pattern-making building was moved across the street to 591 Broadway.

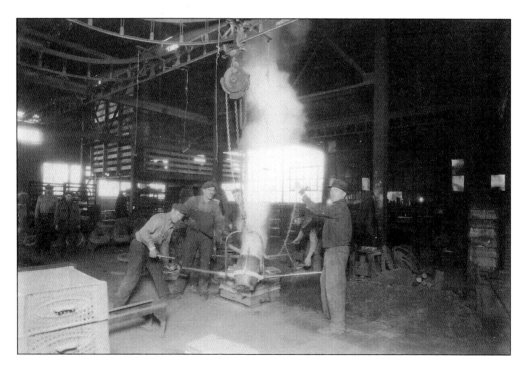

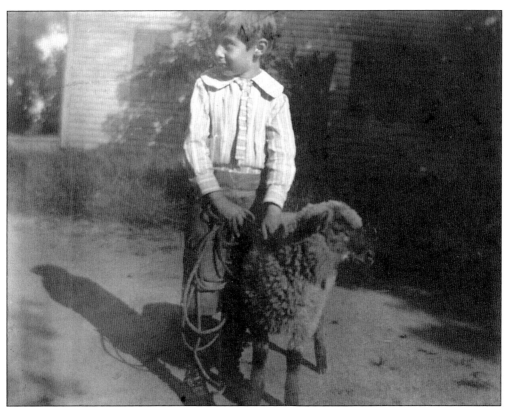

Herman Watson Osborn Jr., born in 1896, poses with his pet lamb at the family homestead along Broadway on the Bedford–Maple Heights border. He purchased his neighbor's equipment for making rubber tips for high-heeled shoes. He experimented with rubber compounds in the family barn and used his mother's kitchen oven to temper the experiments. The Stalwart Rubber Company became one of Bedford's most successful companies. As the company grew, Osborn's sons and sons-in-law joined the company. In the 1958 photograph below, Osborn is circled by (from left to right) his son-in-law Arnold Walter "Mac" MacAlonan, son-in-law Frank Keiffer Byers, his son Edwin Herman Osborn Jr., and son-in-law William Phillip Lindauer. The four men served as vice presidents. The young lady is Osborn's teenage granddaughter Shirley Jean MacAlonan, who worked in the office during summer. When Herman Osborn died in 1961, Arnold "Mac" MacAlonan became president. (Below, courtesy of Shirley MacAlonan Koth.)

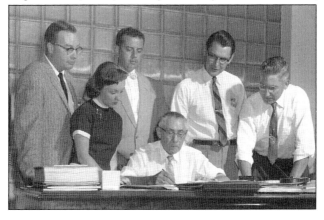

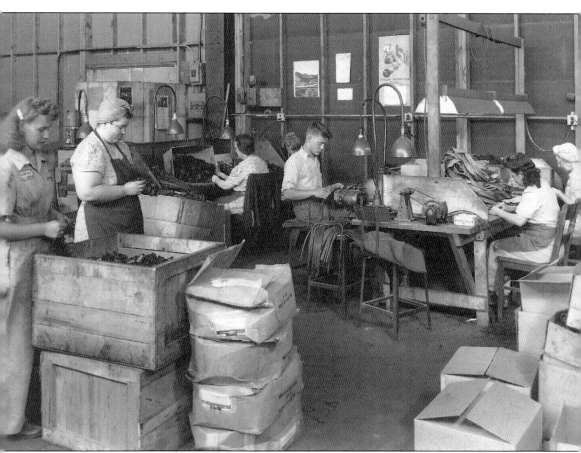

Stalwart Rubber used a portion of the McMyler Interstate complex on Northfield Road for 43 of its almost 60 years. It provided employment for hundreds of local people, some of whom worked at the company for over 40 years. Products included spark plug covers, hoses, tubing, gaskets, and assorted specialized products, including a rubber scraping device used to pluck feathers from chicken carcasses. The photograph shows portions of the rubber making process, which includes compounding, heating, extruding, and trimming the rubber. Over the years, mergers, acquisitions, and outside interests resulted in the closing of the Bedford plant in 1980.

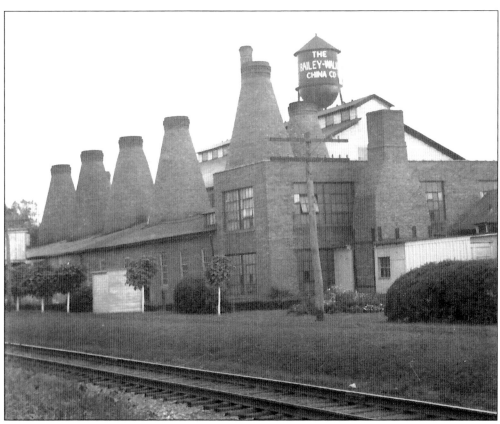

Walker China began production in 1923 under the name Bailey-Walker China Company. The company used a manufacturing facility known as the Bedford China Company, which had been built a few years earlier along the Wheeling & Lake Erie Railroad near Tinkers Creek. Bedford China was in business a short time. Stockholder and treasurer Albert Walker, of Akron, purchased the plant and hired Harry Bailey, an expert in the ceramic industry. The two men built a business. It became a leader in the manufacture of vitrified china, which could withstand rough treatment and high temperatures. These products were in demand by hotels, hospitals, schools, churches, restaurants, and military bases. The company expanded by purchasing the former Standard Steel facility on the south side of the tracks. The photograph shows the plant with the familiar beehive kilns. In 1943, the name was changed to the Walker China Company.

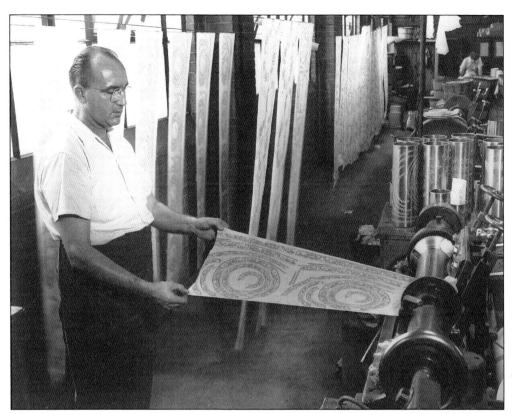

The china manufacturing process involved many specialized jobs. A jigger shaped and smoothed the raw pieces before firing. The design department was headed by George Rudd for many years. The designs were etched on metal cylinders, which could print hundreds of the same pattern. The inked paper patterns, seen in the first photograph, were then cut by hand and applied, or transferred, to the bisque-fired clay items. Some pieces were sent to "liners," whose steady hand painted a line along the edge, as seen in the photograph at right. Beginning in 1967, the company was sold several times and finally ceased operation in 1980.

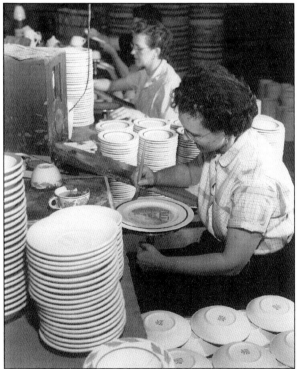

Franklin Oil Company was founded by Frederick Baldwin Senter, who was born in 1864 in Bedford, Ohio. The son of Irish immigrants, Senter graduated from the Spenserian Business College and entered the oil business. Products included lubricants, such as 600-degree Graphite Cylinder Oil, Engine and Dynamo Crystalite Burning Oil, Motor Gasoline, and 650-degree Mobile Oil. The company was acquired by Fuchs Lubricants in 1996. On April 7, 1930, a catastrophic fire started in a storage building and rapidly spread, consuming 250,000 gallons of oil cans. The flames shot 100 feet in the air. Bedford, Maple Heights, and Warrensville Fire Departments fought the blaze for three hours. Firefighters halted three freight trains to string hose across the siding. Fred Miller, a Bedford truck driver, hitched a chain from his truck to three railroad tank cars loaded with alcohol and oil. He pulled the cars away, avoiding additional damage.

Ben Venue Laboratories was founded by R. Templeton Smith, of Pittsburgh, Pennsylvania, in 1938. It was named after a mountain in Scotland and means "Small Mountain" in Gaelic. The original location of the laboratory was on Carnegie Avenue in Cleveland, although the corporate office remained in Pittsburgh. In 1941, the company developed a freeze-drying process for plasma that could be used in field hospitals, as pictured. It also extracted estrogen products from the urine of pregnant mares to accommodate the increased use of the hormone during this time. The company was forced to move when one of the holding tanks leaked, causing damage to a dry goods store below. It found a new site in Bedford at the power plant building of the former McMyler Interstate Company.

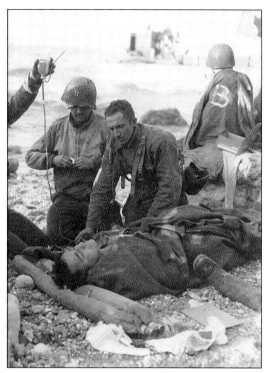

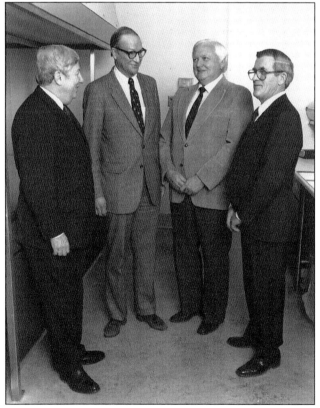

The company received a government contract to manufacture penicillin. The entire output of penicillin went to the US Armed Forces according to Stanley L. Morgan, manager of the plant. The company became a leader in freeze-drying parenteral drugs. Rapid expansion during the 1960s–1980s was led by, from left to right, vice president Stanley L. Morgan, president Kennedy Smith (R. Templeton's son), treasurer Joseph McCormley, and vice president Glenn F. Wickes. It was purchased by Boehringer Ingelheim in 1997. (Photographs courtesy of Boehringer Ingelheim Ben Venue Laboratories.)

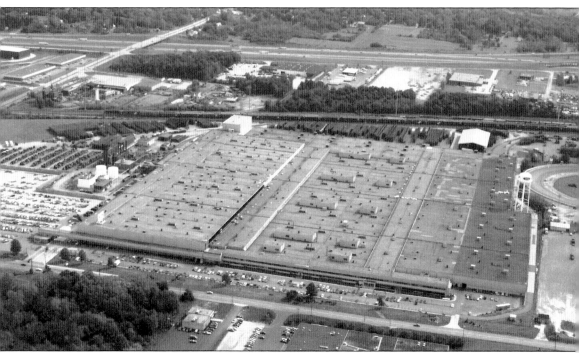

The Ford Motor stamping plant was one of the most anticipated industries in the township. Originally, the stamping plant was known as the Cleveland Stamping Plant; in 1982, the name was changed to the Walton Hills Stamping Plant. The site had a thick shale substrate that could withstand the shocks produced by the stamping process. The Pennsylvania Railroad was at the rear of the property. Ground was broken on October 15, 1953, and production started in 1954. The plant would have 15 major press lines that could stamp body parts for Ford and Mercury vehicles. The plant gradually became automated. Originally, 42 workers operated a production line; it takes two to oversee a line today. (Courtesy of Jean Kainsinger.)

There were many other successful manufacturing companies in the area, but the chapter cannot be closed without mention of the Jack & Heintz Company (JAHCO). During World War II, the nation looked to the Jack & Heintz Company as a model industry for wartime production. William Jack, pictured at right, was an expert in manufacturing and industrial development. Ralph Heintz, below, was an electrical and mechanical engineer. The company was formed in Palo Alto California in 1940, and then moved to the Bedford–Maple Heights border along Broadway on the site of the old Osborn homestead. Jack was born in nearby Newburg, Ohio, and worked in the Cleveland area for several years. Jack was a flamboyant, charismatic man; Heintz was a quiet, behind-the-scenes man. Together, they formed a team that employees honored and respected.

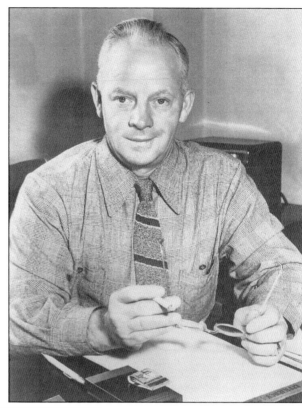

23

Good Place to Work

What makes a good place to work? Swell folks around you . . . good tools, good machines . . . a clean, bright, comfortable plant . . . Sure, all of these, plus a lot of little things, like good parking facilities, hot coffee served twice each shift . . . freedom to do your job and to improve your skills . . . And knowing that there is always a chance for advancement if you do improve your skill enough to rate it . . .

A satisfying lunch, which saves a lot of trouble, any way you look at it . . . Smoking when you want to in most areas of the plant . . . Music at regular intervals to make the day seem brighter . . . But most of all, the knowledge that you are a respected, honored human being, doing an honorable job for good wages . . . That's what makes a man feel good . . . makes him appreciate the fact that he is an American—living, working, prospering—in the greatest country on earth!

Jack & Heintz Company manufactured airplane starters, gyroscopes, automatic pilots, and various motor parts. By 1944, a total of 8,700 people were employed. How the company treated its employees, known as associates, made even more headlines. Employment at JAHCO meant steady wages and good benefits, and employees willingly worked more than 40 hours weekly. Peacetime products included small motors for floor polishers, garage door openers, home workshop power tools, and automatic washers. Jack & Heintz Company also manufactured magnetos for outboard motors and power lawn mowers. In 1946, the company merged with Precision Products. There were several other mergers, which ultimately resulted in the closure of the plant.

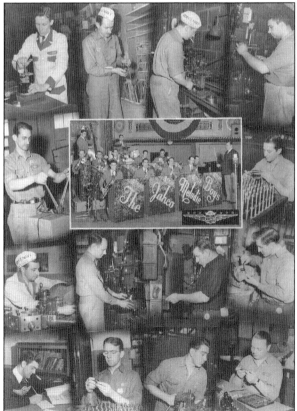

The JAHCO Melodie Boys ensemble was formed by associates who could play musical instruments. The musicians practiced on their own time and performed regularly at company functions. The favorite tune was the "JAHCO Victory Song."

Two
OUR BEST SERVICES

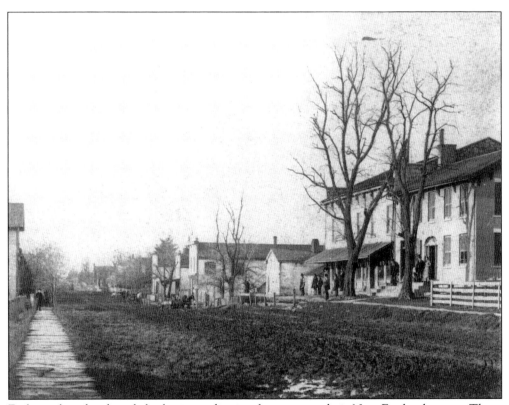

Early settlers developed the business district the same as their New England towns. These distinctive commerce areas were laid out as short blocks with intersecting streets. Sidewalks were an important part of the design, allowing residents and visitors ample opportunity to "meet and greet" each other and window-shop local stores. The Hezekiah Dunham house and adjacent store sit prominently at the right in the photograph.

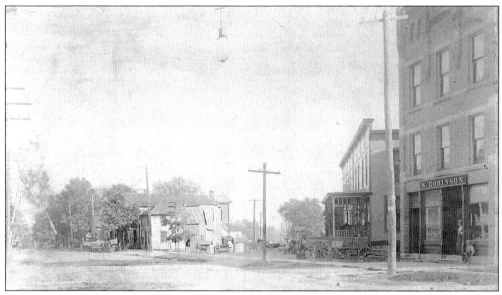

The corner of Broadway and Willis Street was part of the busy commerce district. The photograph was taken before the great fire of September 7, 1893, which gutted 10 businesses along the west side of the road. The blaze was attributed to Foster's Grocery, then in the S.C. Hains frame building. Flames were visible in Cleveland. The fire department in Newburgh raced to assist, but the horses got mired in mud.

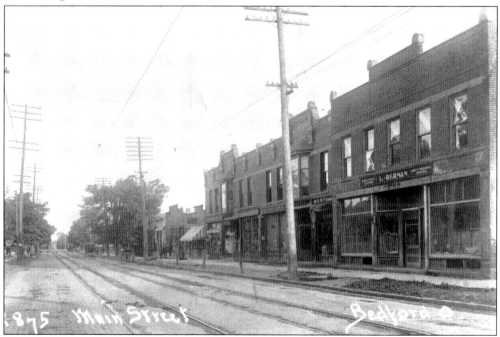

The 1909 photograph looks south along Main Street with the Hains and Guild Block buildings. The Guild building was the first to be constructed after the 1893 fire. The tracks of the interurban line are evident in the photograph. The line transported passengers through Bedford on the way to Cleveland or Akron and beyond. It also brought shoppers to Bedford, and the business district thrived.

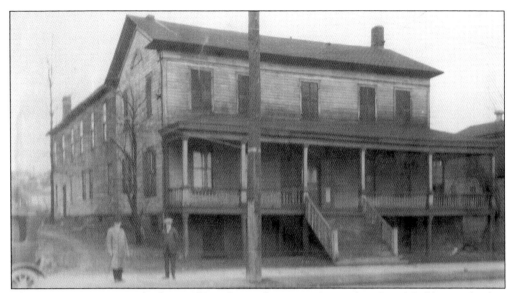

The Fountain House was built in 1832 and served stagecoach travelers. Levi Marble was the first proprietor. It had a tavern, dining room, and rooms for travelers. It also had a large ballroom that local residents used for special events. The building was one of the last wooden structures in the business district and gradually fell into disrepair. It was razed in 1927, soon after this photograph was taken.

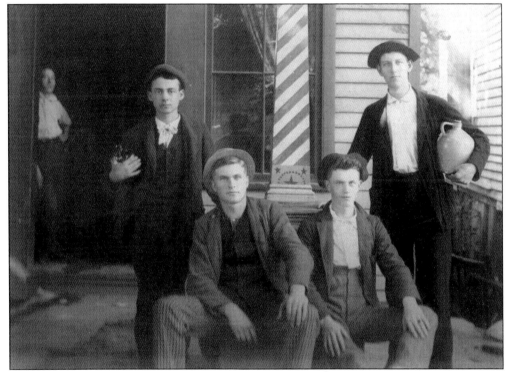

Local fellows pose at Doc Mathews's barbershop. This photograph was taken in 1893. Thomas E. Mathews, known as Doc, was a barber in Bedford for 40 years. Mathews served in the 9th Ohio Independent Battery and was active in the local Grand Army of the Republic (GAR) chapter. He was the last surviving Civil War veteran from Bedford when he died in 1928.

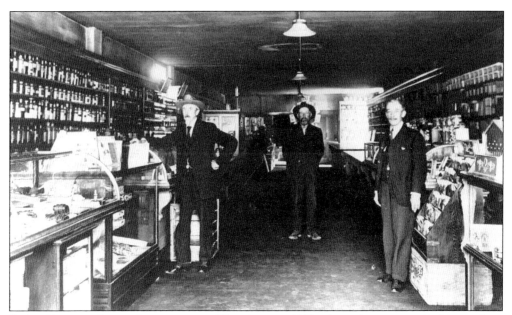

Forbes Store on the northeast corner of Broadway and Woodrow Avenue supplied items from medicines to paints. Robert Forbes (right) poses with customers William Blake (left) and George Laing (center). The Forbes family emigrated from Scotland and operated a farm along Forbes Road. Robert Forbes opened his store in 1861. His son James R. entered the business in 1902 and continued the operation after his father died in 1910. James's brother-in-law John K. Maitland assumed the business and continued it into the 1940s.

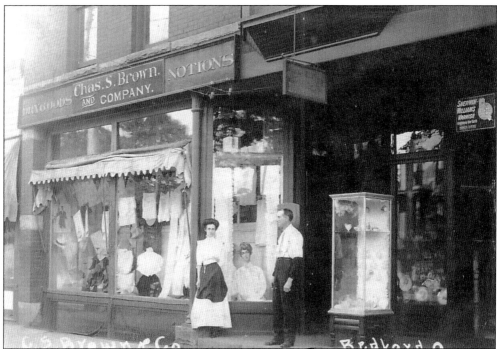

Charles Brown and Company dry goods store offered a variety of items. Brown was active in the community and in the Knights of Pythias. He served as village fire chief from 1893 to 1903.

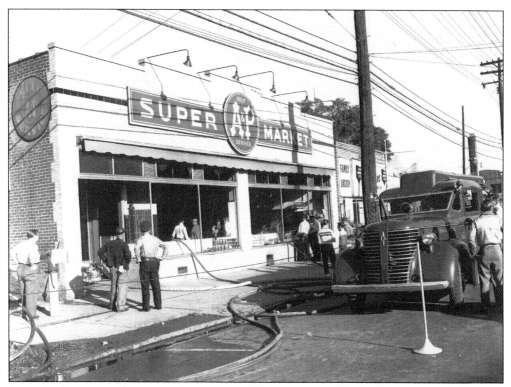

Byron. W. Fromant and son opened a grocery in 1908. Son-in-law Charles Boam joined the firm and operated the grocery for over 50 years. There were 15 grocers listed in the 1929 city directory. The A&P had four locations within the township, including this one on Broadway north of Columbus Road. In the photograph above, a small fire is tended by Bedford Fire Department. In 1955, Yarro Vlasak opened a meat and grocery store at 20 West Grace Street, seen below. The 1920s building originally had a Broadway address when the Bretschneider family operated Home Ice and Fuel Company. "You always get full weight and pure ice," read the advertisement.

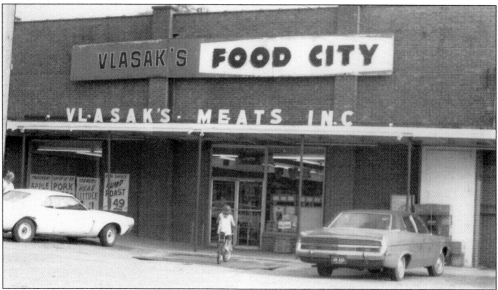

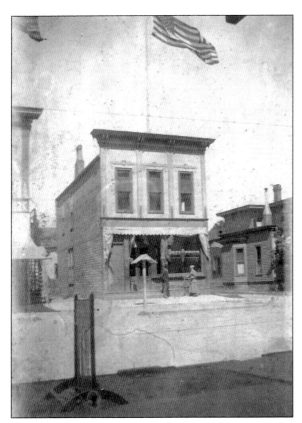

Henry Wilson was appointed postmaster on January 11, 1827. Ziba Willis was appointed on December 19, 1827. Sawmill operator Luther Willis served as postmaster from 1828 to 1833. The 1907 photograph shows the post office at 691 Broadway. The post office below was on the west side of the street at 694 Broadway. People in the photograph are, from left to right, Myrtle Caskey, Eula Garlow, Edward Hathaway Collins, and Lida Wheeler Collins.

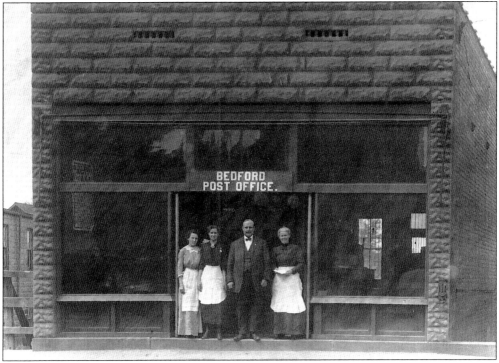

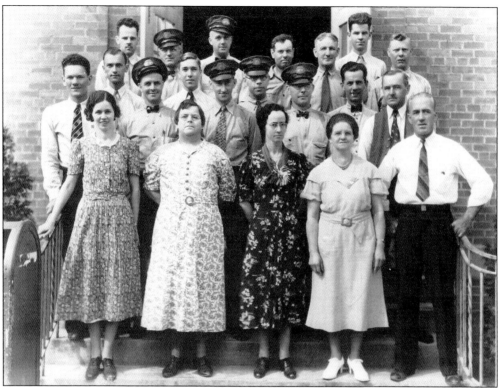

Floyd L. Carr, shown in this 1937 photograph in the first row at the right, served as postmaster. The building was constructed in 1934 and was a source of pride for local residents. Postcards of the new facility were popular. A mural by artist Karl Anderson was commissioned for the lobby. It depicted the transition from farming to industry with several local landmarks.

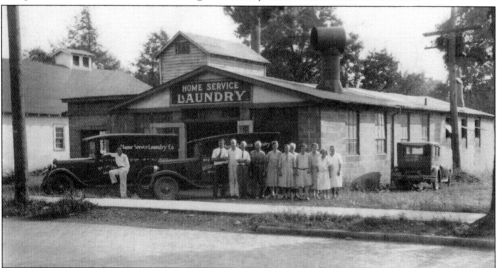

Home Service Laundry served customers from its store on Broadway across from Bedford Cemetery. It offered home pick-up and delivery service with a fleet of trucks. The company advertised, "Our Best Service." Sam Jones operated the family-run business in the 1920s. Sam and his wife, Emma, lived a few yards away in the stone house known as "the Tannery."

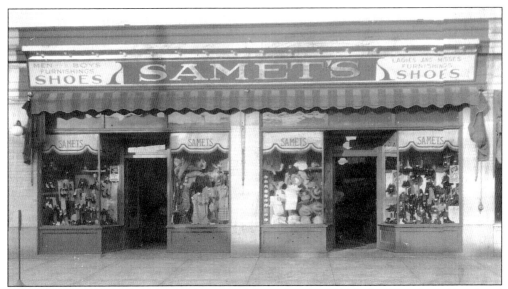

In 1929, the Samet Brothers Department Store opened in the 600 block of Broadway. David and Sanford Samet survived the stock market crash, the Great Depression, and rationing during World War II and remained in business until the early 1960s. Smaller specialized clothiers included Didham and Small. Harry Didham moved from Chagrin Falls in 1909 and opened a men's clothing store with Fred Small. They offered everything from shoes to hats. Didham special ordered coveralls and shoes with brass fasteners for men who worked in the Austin Powder Works. Brass fasteners had less chance of sparking in the volatile environment. Didham retired in 1950.

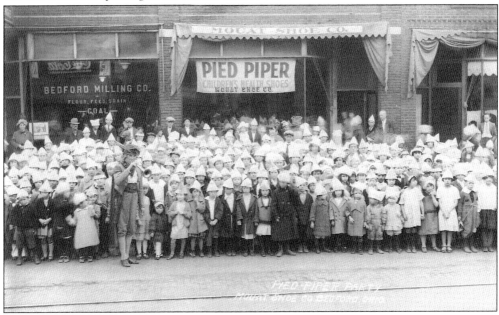

Gavin Mouat moved to Bedford with his bride, Ada, in 1907. He worked for a time at Stone Shoes and then as a buyer for the Halle Company department store. In 1924, he opened Mouat Shoe Company. Children pose outside the store for a Pied Piper shoes promotional. Mouat retired in March 1950, and the store was sold to Bernard Nienalkowski. "Bernie," as he was known, operated Nienal Shoes until he retired in December 2005.

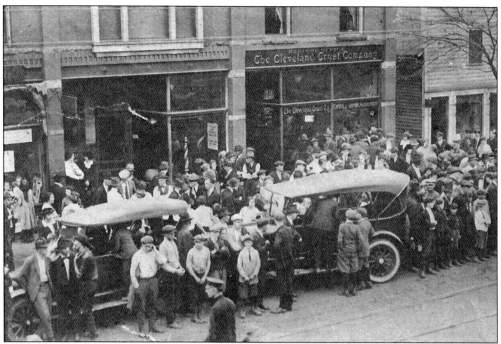

"A Greater Bank for a Greater Bedford," was the motto of the Cleveland Trust Company. The bank originally opened at 688 Broadway in the Van Allen Block building. One of the exciting episodes in Bedford history happened when "Jiggs" Losteiner and gang robbed the bank on October 21, 1920. Local residents saved the day with one of the biggest shoot-outs in memory. It was known as the Great Bank Robbery of 1920. A newspaper photograph shows residents gathering at the scene after gunfire ceased. The company built a new bank with an impressive marble facade and interior four years later located a few doors north at 680 Broadway.

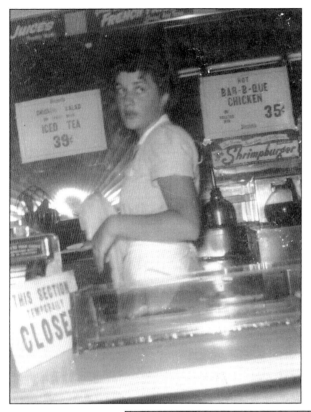

Marshall Drugstore was located on the northeast corner of Broadway at Tarbell. The brick building, known as the Marshall Building, had an upper floor for offices. The soda fountain inside Marshall's was a popular spot for students at nearby Bedford High School. Helen Pfenninger, Bedford High class of 1955 and high school majorette, worked at the soda fountain after school. (Courtesy of Helen Pfenninger Batko.)

Another favorite spot from about 1934 to 1963 was the M&M Dairy at 698 Broadway. The shop was owned by Lawrence and Glenda Miller, pictured, and Glenn and Pearl Metz. Miller, or "Shorty," as he was affectionately known, graduated from Bedford High in 1927 and settled back home after finishing college. Miller was also the fire chief. The fire station was across the street from the store.

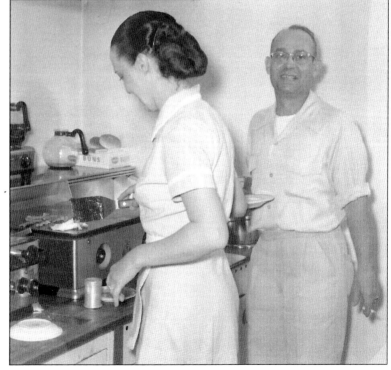

John Avery and other young men sold ice cream from pushcarts for the M&M Dairy. Inside, customers were served by waitresses in crisp uniforms who adhered to stringent rules of conduct. In 1967, the Midtown Restaurant opened at 698 Broadway. It was a favorite place for the locals to eat and catch up on the events of the day. In the 1920s, the alley next door led to the Marmon & Roosevelt Motor Car dealership.

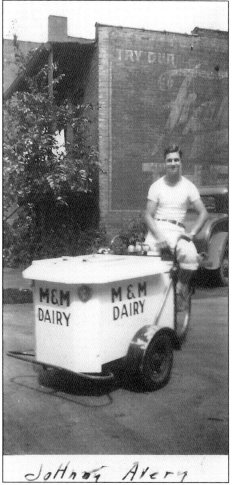

Jack Allen operated the Pee Wee Cottage at 909 Broadway in the 1950s and 1960s. The restaurant was one of the early diners serving lunch and dinner. The menu listed chicken and steak dinners and barbecue ribs, but locals say the great hamburgers kept diners coming back.

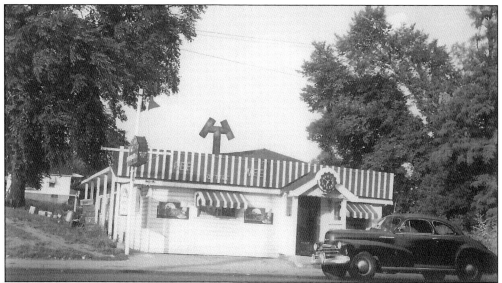

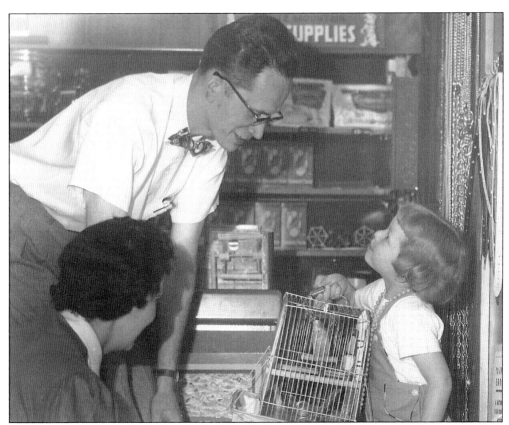

Hinckley's Ben Franklin Store was located at 675 Broadway when this photograph was taken in September 1956 by photographer James Venditti. Delmar Hinckley offered a contest for bird owners; the first parakeet to say, "Ben Franklin" won an assortment of parakeet supplies, a year's subscription to the *Bedford Times-Register*, and a week on the payroll with a $10 salary. Here, Hinckley and employee Norma Ferrara meet the winner, Dickie, who was owned by Starlett Grill. The parakeet was trained to say, "Ben Franklin—God bless you—five and ten."

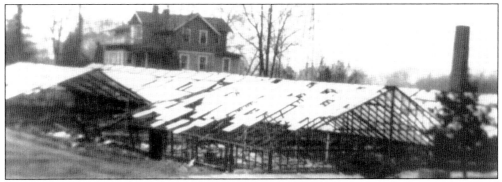

Lee Greenhouse at 171 North Street supplied floral arrangements and gardening needs. Alfred Ernest Lee's family emigrated from England via Ontario, Canada, around 1865. The family purchased seven acres and built a home and greenhouse. During holidays and special events, parents, children, and grandchildren all helped. Operating the greenhouse was a year-round job beginning in January when hundreds of seeds were planted. A damaging snowstorm in 1952 caused severe destruction, and the business did not rebuild.

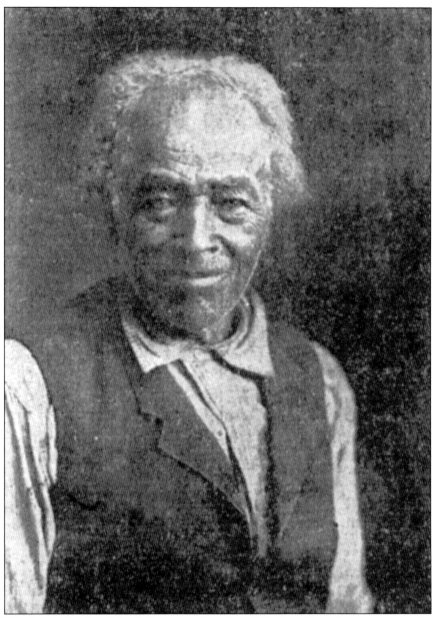

The Tibbs family lived on North Street at the edge of the Lee Greenhouse property for many years. Julius Caesar Tibbs was the patriarch of the family. Tibbs led a remarkable life and was a respected resident in the community. He was born in Tuckahoe, Virginia, in 1812. According to the Burns family, which owned a farm in the south portion of Bedford Township, Tibbs, an escaped slave, was found living in a hollow tree. With help, he and his wife, Clarissa Bongher, settled in Bedford and raised a family. Tibbs worked for Burns as a laborer, and his family later helped at the Lee Greenhouse. Tibbs became well known for his orations, philosophy, and humor. His death on February 7, 1903, was duly noted in a Cleveland newspaper with a lengthy obituary. The grainy photograph from the unnamed Cleveland newspaper is the only known image of Tibbs. He is buried in Bedford Cemetery next to his wife and their daughter Anna, who died of pneumonia within hours of her mother in 1899.

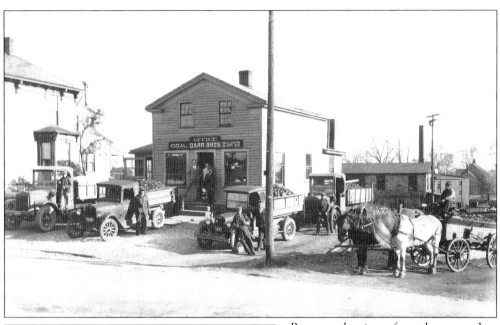

As you journey through life
You may see by the way,
All the "cheap but good" brands—
And each have their day;
But I'm willing to bet
You'll a long way go
Before you find coal
 to equal "Hi Lo."

Hi Lo is the wonder coal
 from old Kentucky

C. F. Miller

Coal
Builders Supplies

23 W. Monroe St. Bedford, O.

Between the time of woodstoves and gas furnaces, coal heated homes. It was delivered by truck and dumped into basements via a coal chute. Longtime Bedford historian Dick Squire referred to this as "the housewife's nightmare" because of the dust and dirt. Maintaining a comfortable temperature required periodic trips to the basement to add coal. George W. Carr opened Bedford Elevator and Coal Yards in 1906. It became a family business known as Carr Brothers. The photograph shows the company located at South Park and Willis Streets.

The 1938 directory lists Chas. Svec, Alexander Coal Company, Bedford Ice & Fuel Company, Lipstreu Coal & Feed Company, H.B. Myers Company, T.L. Ice & Fuel Company, and C.F. Miller Coal. F.S. Curtiss operated the Glendale Coal Yard. Bedford Milling advertised, "Pocohontas, Deerfield, Massillon and Hard Coal." H.B. Myers Coal Company served Maple Heights residents. Most of these companies were located along the railroad tracks where coal came by railcars from the mines. C.F. Miller advertised a high-grade coal from Kentucky.

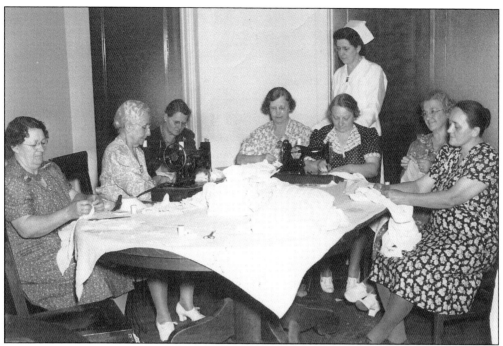

Bedford Municipal Hospital on Blaine Avenue was constructed in 1927. When *Cleveland Press* photographer Walter Kneal visited Bedford for a photographic essay in 1941, he found the Hospital Guild repairing sheets. From left to right are Mrs. R.C. Howard, Mrs. Chas F. Cowan, Mrs. L.B. Gremillion, Mrs. Homer Slates, Mrs. W.T. Bachman, Mrs. E.R. Lamson, Mrs. C.R. Bradley, and hospital superintendent Lucy E. Farquhar. The guild supplied thousands of volunteer hours and raised funds for equipment and building additions.

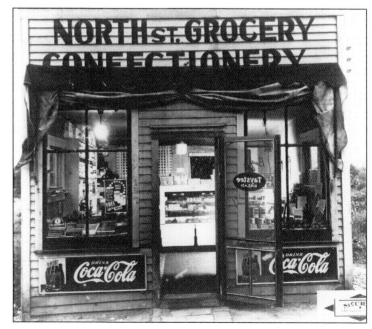

Throughout the township, small corner stores served local residents. Just north of the Lee Greenhouse was a small convenience store first known as the North Street Grocery then the Big & Little Store. The refrigerated food case visible through the door in the photograph had a convenient payment plan for the owner. A coin meter was attached to the cooler; the store owner would drop 25¢ into the meter as payment every day.

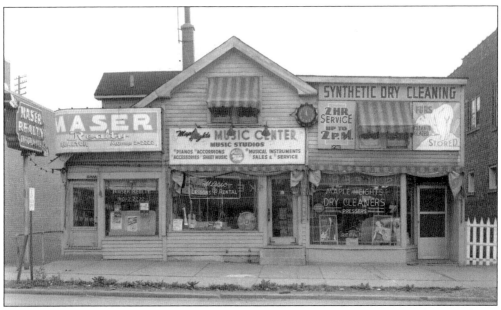

The 1940s photograph above shows businesses on Broadway southwest of Libby Road. Antonio Casale started Maple Heights Dry Cleaning and Shoe Repair as a shoe repair shop in the late 1930s. The dry cleaning portion was added in the early 1940s. If a local family was experiencing hard times, Casale would repair their shoes without charge. Son Domonick worked in the family business after school. When his father purchased a truck, 15-year-old Domonick handled pick-up and delivery. In 1950, Antonio died, and Domonick inherited the family business. He continued until November 1958, when he sold it to enter the insurance business with Robert W. Strachan. (Both courtesy of Domonick Casale.)

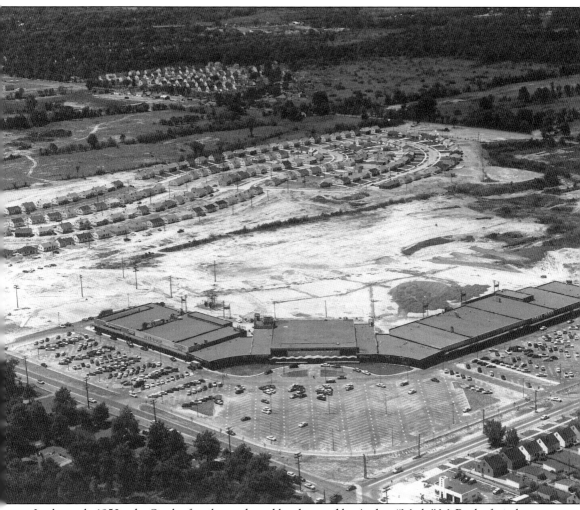

In the early 1950s, the Siegler family purchased land owned by Arthur "Micki" McBride, founder and owner of the Cleveland Browns. Construction began on the first phase of Southgate Shopping Center. The weeklong grand opening in May 1955 featured radio personalities Tom Edwards, Bill Gordon, and Bill Randall, who broadcast their shows from the center. The Fontane Sisters and Myrus, a mental telepathist, performed. A mile-long ribbon was used for the ribbon cutting. Tenants included the May Company, Sears, JC Penney, and Woolworth's. Southgate was advertised as the "Midwest's Greatest New Shopping Center" and "Cleveland's Suburban Downtown."

Several stores served residents in Maple Heights as it developed in the late 1920s and 1930s. Charles and Emma Kralicek operated a dry goods store in a building attached to their home at 17051 Libby Road. Next door, Anthony Kralicek was the branch manager of the Workingmen's Co-operative Company, a meat and grocery store. Perakek Brothers Grocery served customers on Broadway near Libby Road. By 1957, the Maple Heights directory listed Art & Tony's Market, Calafiura Food Market, Fisher Brothers, Foodtown, Galaski's Groceries, George's Food Market, and Grill's Grocery and Delicatessen. Larger markets included A&P Food Stores, Henry's Square Deal Supermarket, Kroger Company, and Pick-N-Pay. The photograph was taken in the 1990s when this building served as a beauty salon. (Courtesy of John Straka.)

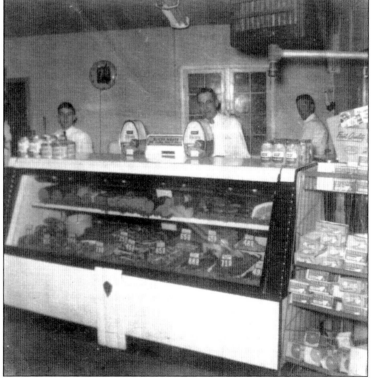

From left to right, John Malone, Walter Elbrecht, and Walter Tuennerman Jr. serve customers in the 1950 photograph. Elbrecht leased the meat department in John Schwind's grocery. Schwind opened the store in the late 1930s at Broadway and Tryon Road. His three sons helped run the business. Some of the prices in the case include ground beef at 71¢ per pound, bulk sausage at 48¢ per pound, and round steak at 88¢ per pound. (Courtesy of John R. Malone.)

Perhaps the business with the most impact involved automobiles, which evolved from Bedford's role as a stagecoach stop. Residents embraced the new machines despite muddy roads. Ohio speed limits were 15 miles per hour in business districts, 25 miles per hour in residential areas, and 35 miles per hour outside of corporation limits—nothing higher. A new showroom for the Hupmobile is advertised in 1928.

The Bedford Hupmobile, Inc.

announces the opening of their

New Show Room and Service Station

at 9 - 17 North Park Street, Bedford, Ohio

Thursday March 15, 1928

Beautiful, conveniently located and managed by Miller Brothers, formerly of Bedford Milling Co.

The Wonderful New Century Hupmobile

will be on exhibition, with many models to choose from.

It is "Some Car" with style, and performance unsurpassed, so be sure to come and see it before buying a new car.

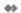

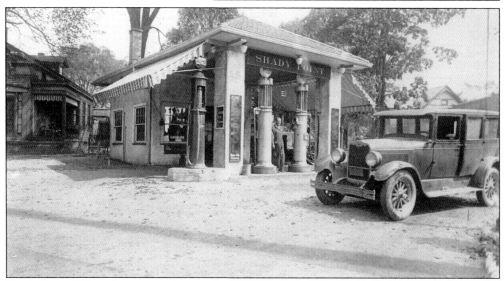

Shady Point Filling Station on the corner of North Street and Columbus Road was one of the earliest service stations. The Horton brothers owned the station, which in 1924 advertised, "High grade gasoline, oils and greases. The best equipped station in Ohio/Modern restrooms/Don't Fail to Stop." On the back of the photograph, a description is given: "Gas was drawn into a five gallon bucket through a chamois skin to get the water out and put into a car with a funnel."

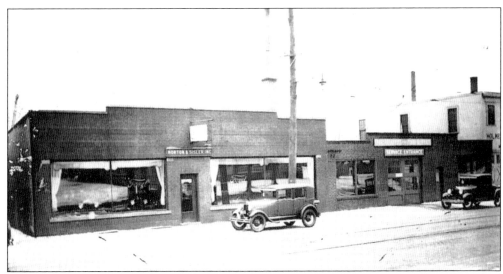

Early car entrepreneurs Lynn L. and Ralph E. Horton sold Fords in the 1920s and then branched into other dealerships. An advertisement at the time read, "When you think of Chevrolet, Think of Horton's." The photograph above shows 580 Broadway as Sisler Horton Ford, a one-story building. In the photograph below, it is Ralph Horton DeSoto-Plymouth with a second floor added. Lynn Horton sold Chevrolets. William Horton, Floyd Mosher, and Thomas Lally joined the dealership. It was renamed Mosher-Lally when Lynn Horton retired. James Fiedler became a business partner, and it was renamed Lally-Fiedler. When Fiedler retired, the dealership was renamed Lally Chevrolet. (Both courtesy of Leslie Horton Gladfelter.)

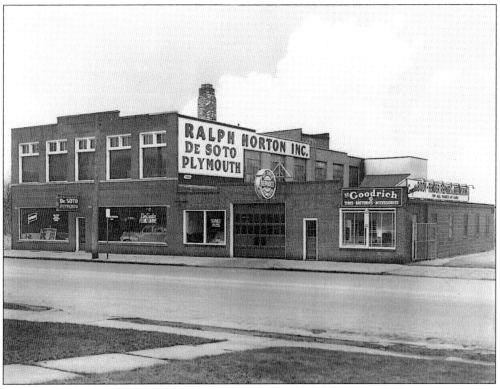

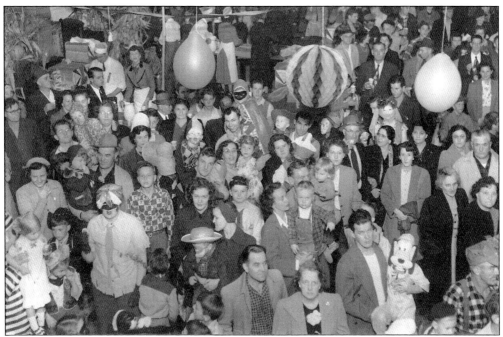

As showrooms increased in size, automobile dealerships expanded north along Broadway toward Rockside Road. Elliott Dodge's new building was large enough to hold a party. This 1950s photograph shows the annual dealership-sponsored Halloween party. The dealership also had a duck pond; children fed the ducks while parents shopped for an automobile.

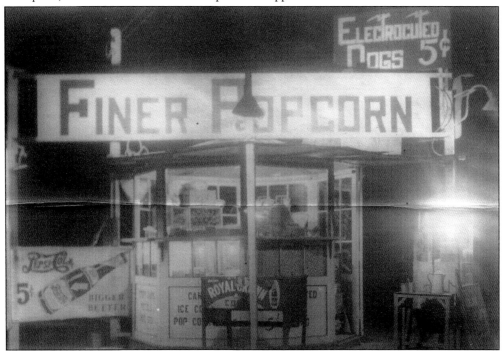

New drivers could stop at Finer Popcorn on the southeast corner of Broadway at Grace Street, which served "electrocuted" hot dogs for 5¢, as shown in this 1939 photograph.

Thanks to public transportation and better roads, many residents, like Bert Zahn Sr. (left), lived in Bedford and worked throughout northern Ohio. Zahn was a pioneer in graphic arts development and training who managed the graphic arts division of Glidden Corporation. His 1956 textbook *Silk Screen Methods* is the bible for the industry. During World War II, the US Armed Forces relied on Zahn to teach silk-screen printing to military personnel, such as Pfc. Francis Thomas (right). The process was fast and efficient for printing posters and signs in English for the troops in foreign countries. Zahn was born in Milwaukee, Wisconsin, where he learned early sign-painting techniques.

Three

RENT MONEY WASTED, OWN YOUR OWN HOME

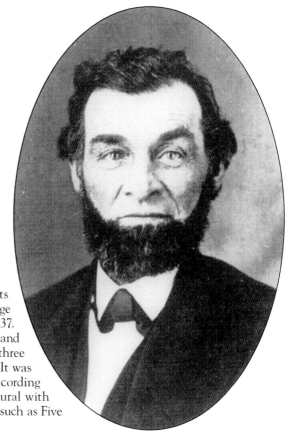

Hezekiah Dunham encouraged residents around Lot 46 to form a village. The village of Bedford became self-governing in 1837. Dunham and his wife, Clarissa, deeded land for schools and churches as well as almost three acres for use as Bedford Public Square. It was to be "used as a public square forever," according to the deed. Outlying areas remained rural with smaller, loosely organized communities, such as Five Points, Egypt, and the Grove.

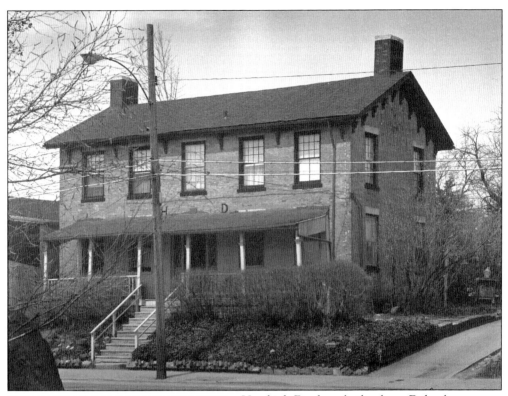

Hezekiah Dunham built a large Federal-style home on the Turnpike Road, now 729 Broadway. It was primarily a residence, but even in Dunham's time, records indicate that he and his wife let rooms to boarders. There were several owners over the years, including Frank Nyerges, an immigrant tailor who moved his family into the house in 1917. The home is seen before restoration in the 1990s with the distinctive letters H and D.

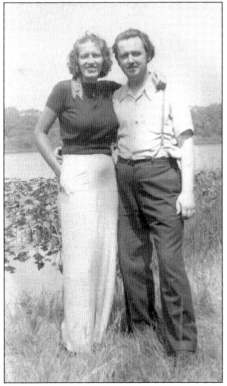

Frank Nyerges's daughter Anne married artist Richard Sedlon, both seen in this 1950s photograph. They lived in the house for many years. Sedlon produced artworks in sculpture, canvas, and wood. He was born in Philadelphia in 1900 and moved to Cleveland with his family. Sedlon was a commercial artist for Morgan Lithograph Company.

Phinamber Benedict, the son of Daniel Benedict who gave Bedford its name, built one of the earliest homes at 52 Center Road in 1840. The house was constructed at North Street and Columbus Road but was moved for commercial expansion of the corner. Andrew Jackson Hensey raised his family in the house in the late 1800s. His youngest daughter, Hilda, and her husband, Harry Hoopes, occupied it in the early 1900s. Some of the Hensey children pictured here are, from left to right, Harriet, Otto Ray, Andrew Fitch, Vincent Bruce, and Ada May.

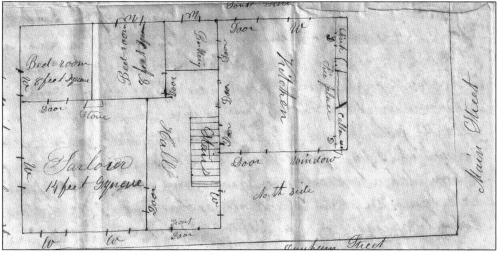

"O we are heartily sick of this Ohio and wish we were at the east where there is some honesty amongst the people," wrote Henry Sterns, a tailor, in a letter to his father. Sterns and his bride, Martha, built a home on Woodrow Street, then known as Dunham Street, in 1837. Sterns sent the sketch of the rooms to his father in Massachusetts. He announced the birth of his first child in a letter written on June 29, 1839: "He is a genuine down easter—a real Yankee there is not a particle of Buckeye about him." The family returned to Massachusetts.

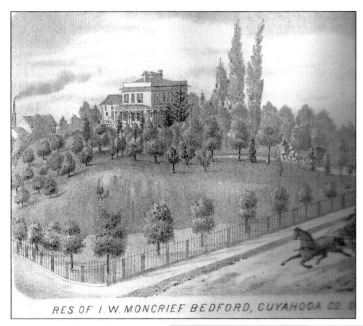

The Moncrief house at 22 East Monroe Street is better known as the home of William O. Taylor. The lithograph is from D.J. Lake's 1874 *Atlas of Cuyahoga County, Ohio*. Isaac W. Moncrief, born in Massachusetts, married Emma Heston. They lived only a short time in Bedford. Taylor purchased the home after living in a house on the Taylor Chair Factory property. That house was moved to the bottom of Union Street where it stands today as part of a tavern.

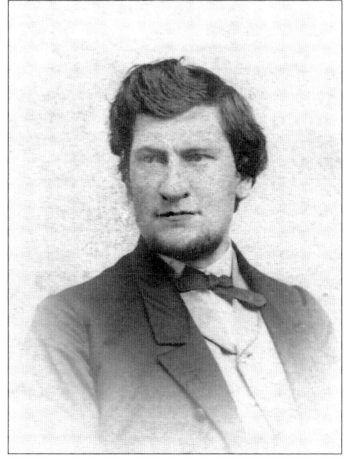

West Monroe Street was the birthplace of one of America's most notable painters Archibald MacNeal Willard, born on August 26, 1836. His father, Samuel, was the pastor of the Bedford Baptist Church. Willard painted one of America's most beloved paintings, titled *The Spirit of '76*. His father's image is the central figure in the painting. Willard's popularity as a painter in the 1800s and early 1900s kept him comfortably employed. The photograph of Willard is from the Willard family Bible.

Considered the oldest house in town, the Milz house at 35 Columbus Road was built in the early 1830s. The Milz family emigrated from Switzerland. The house is also known as the Parsons house because of a tragic murder. Dr. John Hughes, a Cleveland physician, fell in love with a young Bedford woman named Tamzen Parsons. The couple traveled to Pittsburgh and married. Soon after, Parsons learned that Hughes was a married man and father of three. Relatives traveled to Pittsburgh to rescue her, and Hughes spent several months in jail on a bigamy charge. On August 9, 1865, Hughes hired a driver to take him to Bedford. He stopped frequently to drink at local taverns. Hughes found Parsons walking along Columbus Road. She ran for safety to the Milz house's front stoop. He fired two shots at point-blank range. Parsons died instantly. After capture by several Bedford men and a sensational trial, Hughes was found guilty. A portion of Sheriff Felix Nicola's transcript reads, "I did on the ninth day of February A.D. 1866, between the hours of ten o'clock of the forenoon and two o'clock of the afternoon of said day hung the within named John W. Hughes by the neck until he was dead."

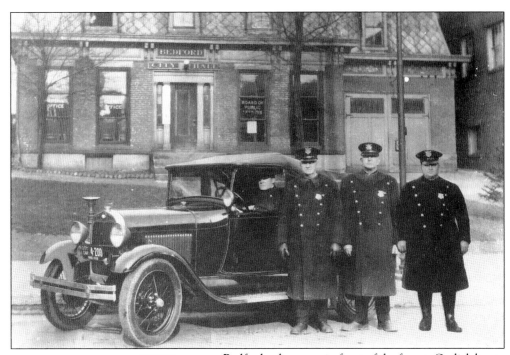

Bedford police pose in front of the former Garlick house in the 1930 photograph. The building was located at 683 Broadway and served as the Village Hall from 1916 to 1954. Dr. Theodatus Garlick (pictured) lived in the home with his third wife, Mary Chittenden, from 1873 to 1884. Garlick was born in Middlebury, Vermont, on March 30, 1805, and received his medical degree from the University of Maryland in 1834. He practiced medicine in Youngstown before moving to Cleveland to form a partnership with Dr. Horace Ackley. Garlick was an early pioneer in plastic and facial surgery, who had wide interests; his treatise on the artificial propagation of fish is the foundation of today's fish farming industry. He experimented in daguerreotype photography and was a strong abolitionist who withdrew his church membership in Youngstown because it did not support the cause. He died on December 9, 1884. The house was razed in 1964.

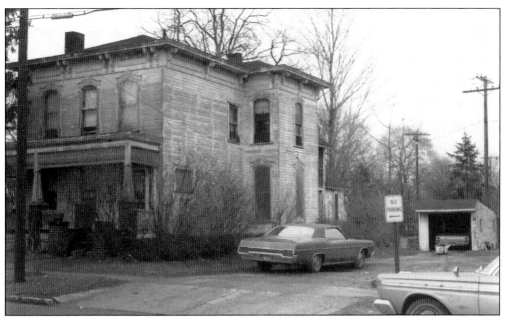

The Tarbell-Strathdee house was constructed in the early 1870s by Dr. Solomon W. Tarbell, a Bedford physician from Connecticut. His widow resided in the home until it was sold to make way for commercial development along Broadway. Jack Strathdee, a local blacksmith, purchased the home and arranged for Lowney Brothers Company of Cleveland to move it a few yards east. Bedford librarian Caroline Olynyk took the photograph in 1973 when the home was on Woodrow Street. It was razed in the late 1990s.

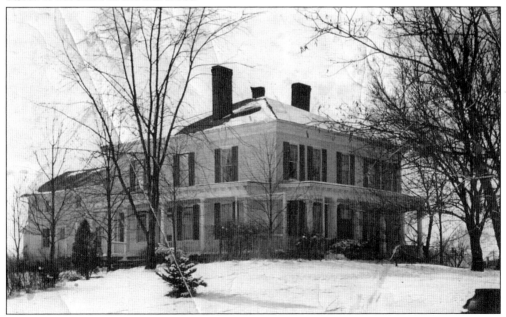

Hillhaven at Broadway and Union Street was built by Hezekiah Dunham in the 1830s. Dunham's daughter Betsy and son-in-law Dr. John Peter Robison lived in the house. Robison was a physician, but his fortune was made in the meatpacking business. A frequent guest was James A. Garfield. The home was a stop along the Underground Railroad.

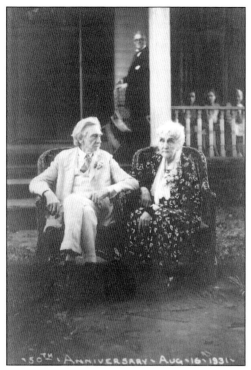

Another owner of Hillhaven was Col. William Blake, who made his fortune in manufacturing stoves. Blake's wife, Marietta, was the daughter of Dr. Theodatus Garlick. Their daughter Theodora, who was named after her famous grandfather, poses with her new burro and friends Trissa Hubbard and Bruce Taylor in 1894. Theodora taught school for several years, lectured on Catholic literature, and was the editor of the *Bedford News Register*. Hillhaven was razed in 1961.

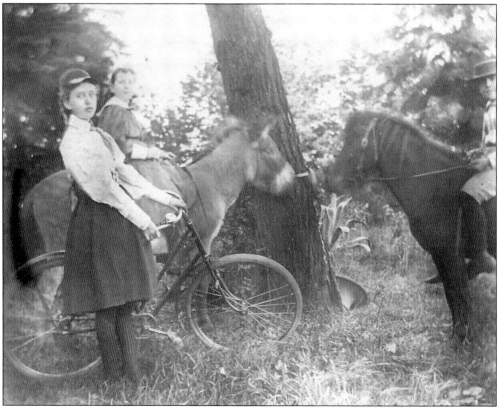

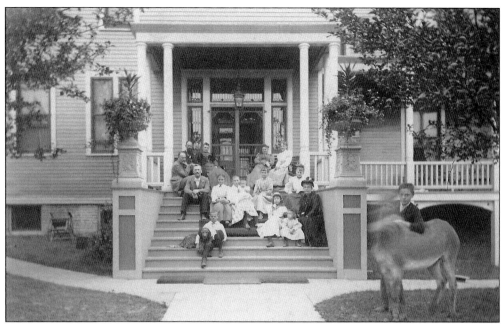

Paul Schneider, owner of Best Foundry, built a home along Main Street on the section called the Twinsburg Road. The estate had manicured lawns, wooded trails, and intricate floral beds. The Schneiders enjoyed boating on a large lake on the property. Schneider was an avid bowler and had a single lane installed in the basement of his home. A league was formed with colleagues of equal stature, and for 10 years, the team met on Friday evenings to bowl and socialize. In 1905, Schneider donated a portion of the property along Paul Street for the construction of St. Mary's Catholic Church. When he died in 1909, the property was sold to developer Bernard Schatzinger, who donated a large portion, including the mansion, to the Catholic diocese. The home was used as a convent for many years.

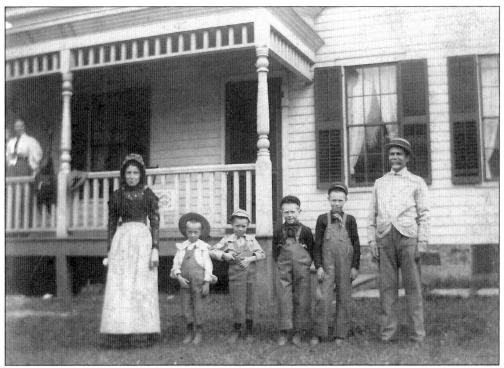

James Handyside Sr. operated a feed and seed mill in Cleveland. A family story recalls that one of his clerks was John D. Rockefeller. Handyside and his wife built a summer home on the Twinsburg Road, the south portion of Broadway by Tinkers Creek. They eventually moved there year-round and raised four sons in the home—Wilson, George, Douglas, and James Jr. James Jr. and his bride, Caroline, moved into the family home and lived there until it was razed to reroute Broadway.

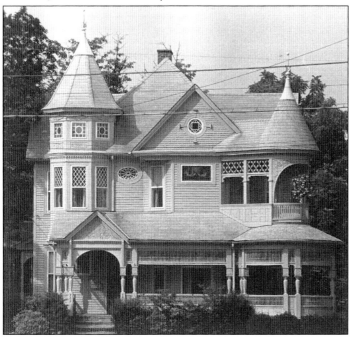

The Gates Handyside house at 762 Broadway was designed and built by Washington Gates for his son Holsey and bride. Gates purchased Luther Willis's gristmill at the Great Falls of Tinkers Creek and had other milling operations in parts of the Western Reserve. Washington's son Holsey was in charge of the Bedford mill. The home was the first house constructed with electric wiring in 1893. It remains the family residence and is listed in the National Register of Historic Places.

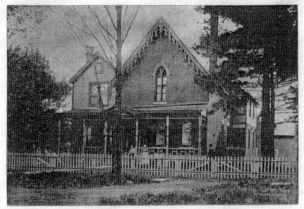

THE GLENDALE ALLOTMENT
OWNED BY JAMES A. ANDERSON
BEDFORD, OHIO

Bedford is without doubt the most popular suburban town within reach of Cleveland. Only 12 miles from the public square and 30 minutes ride on the Cleveland, Canton & Southern Railway from their Ontario St. Depot. Also located on the Cleveland & Pittsburgh and Cleveland, Akron & Columbus Railroads.

No town in Northern Ohio presents finer scenery than can be found in and around the village of Bedford. Good building lots can be secured on the Glendale Allotment from $200 to $400 each, within easy reach of good churches, schools and stores, and free from the smoke, dirt, dust and noise of the city. Here you can breathe the pure air, unadulterated by the obnoxious gases surrounding a large city.

JAMES A. ANDERSON'S RESIDENCE ON THE ALLOTMENT

SPECIAL NOTICE Now is the time to invest, as property is rapidly advancing in value, and all persons desirous of looking over the Glendale Allotment with a view of securing a suburban home will be conveyed to and from Bedford free of charge. For circulars, plats and full information, call on or address

LEONARD HERSHEY 832 SOCIETY FOR SAVINGS, CLEVELAND, OHIO

The Glendale allotment was one of the area's earliest planned developments. James Anderson purchased 35 acres in 1890 and built a home at the corner of Main Street and Glendale Avenue. He divided the remainder of the property into lots and joined efforts with real estate developer Leonard Hershey, who was also mayor of Bedford. One of the benefits of living in the Glendale allotment was being able to board the ABC interurban trolley at the Glendale station and arrive in Cleveland a few minutes later, as seen in this 1907 photograph.

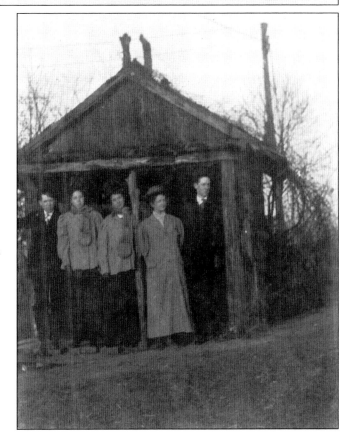

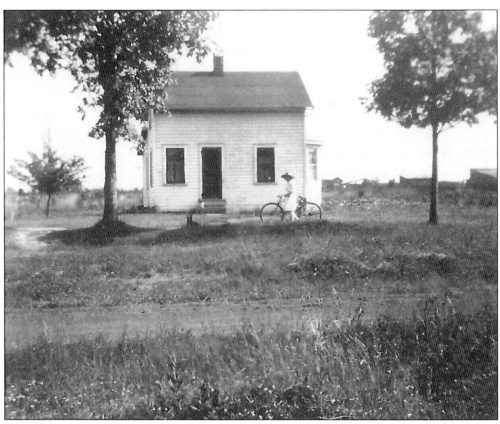

In 1912, the Pratt family built a modest house at 244 Glendale Avenue. Margaret Pratt poses with her bicycle in front of the home in 1919. Members of the family lived in the home for over 80 years. William H. and Edith Petrie Brown built a house at the corner of Glendale Avenue and Turney Road. Edith Petrie Brown was a family physician who practiced in Bedford from the 1930s into the 1960s. It was not unusual for her doorbell to ring with a neighbor seeking assistance. Edith Margaret Petrie was born in Conneaut Lake, Pennsylvania, on June 7, 1900. She was chief of staff at Bedford Hospital and served as president of the American Medical Women's Association. She was an outspoken educator about alcoholism. She directed the immunization program in Kenya, which is credited with saving thousands of lives. She died in 1985. (Above, courtesy of the Pratt family; left, courtesy of W. Stanley Brown.)

By 1910, Main and North Streets were completely paved. The route to Bedford was known as the "Bedford Run" and was a pleasurable Sunday motoring excursion. Advertisements for automobile routes, railroad passenger service, and the interurban light rail system encouraged people to move to Bedford. Farmland west of North Street was developed as the Bedford Heights allotment, including Ellenwood, Wandle, Gould, and Eldred Avenues. This advertisement dates to the 1920s.

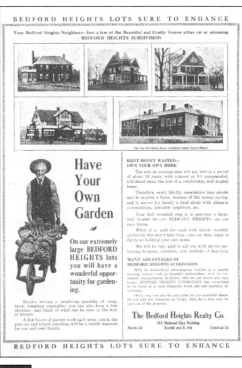

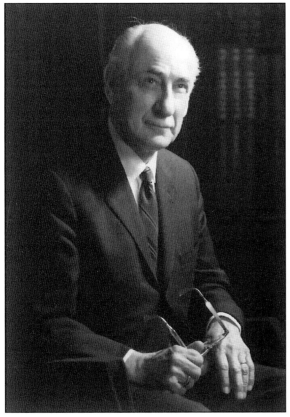

Ralph Bell Sr. and his wife, Ruth Prestage, built a home on Wandle Avenue for their family. Born in Naylor, Missouri, Ralph settled in Bedford after obtaining his law degree from Western Reserve College of Law. He served on the village council and helped write the city charter. He founded and edited the *Bedford Times*, a local newspaper, and in 1932 became Judge Bell, the first judge of Bedford Municipal Court, retiring in 1960. In World War II, Bell was a major in the US Army in France. Bell died on October 30, 1987.

Elmer Flick lived at 144 North Street during his years as a professional baseball player. Flick was born in Bedford on January 11, 1876, and had an early talent for the game. He played with several minor league teams before signing with the Philadelphia Phillies in 1898 as an outfielder. His batting average in 1900 was .381; only Honus Wagner had a better average that year at .378. In 1902, he joined the American League team in Cleveland. A series of health problems caused his retirement in 1911. Flick and his wife, Rose Ella, whom he met and married in Indiana, settled in Bedford and raised five daughters. His brother married Rose Ella's sister. In retirement, Flick excelled as a horseman and hunter. He built several homes in town. His excellent record as a professional ballplayer was recognized in 1963 when he was inducted into the Baseball Hall of Fame. He died in 1971 at the age of 95. This photograph shows Flick with unidentified admirers in June 1966 at the dedication of Flick Field.

Mary Cowan moved with her parents to 84 Ennis Street. After graduation from Bedford High School, she attended Denison University where she graduated with degrees in chemistry and zoology. Her postgraduate training and degrees gave her excellent qualifications to serve as a forensic scientist with the Cuyahoga County Coroner's Office. Her remarkable career began in 1939 and spanned 56 years. Specializing in bloodstains, Cowan was a senior medical technologist in the trace evidence department. She testified in numerous trials as far away as Manila in the Philippines. Besides her long career in the coroner's office, she was assistant professor of legal medicine at the Medical School of Case Western Reserve University. She also taught for the Ohio Peace Officers Training Council. Cowan lectured for the American Academy of Forensic Sciences. Each year, the academy honors one person who exemplifies the standards of forensic science with the Mary Cowan Award. Cowan lived in the house her father purchased on Ennis Street. She died in 1998.

The development off of Grand Boulevard and Bexley Drive was known as the Metropolitan Park development in the 1920s. The Hubbell brothers, both attorneys, built the first homes; Harrison built on Grand Boulevard, and Charles, known as Ned (pictured at left), built on Bexley Drive.

Rapid development of more homes in the area in the 1950s was not without difficulty. Natalie Drive resident Mrs. John Sinko wades in floodwater after a summer storm in 1953. Other neighborhoods in Bedford included the Bedford Farms allotment with Forest Drive and Oakwood, Mapledale, and Edgewood Avenues. The High Street area was known as the Clearview Heights development. The Clearview Heights Sewing Club met regularly in homes in the 1920s.

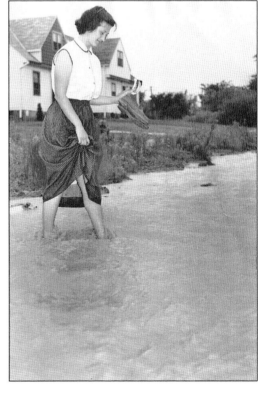

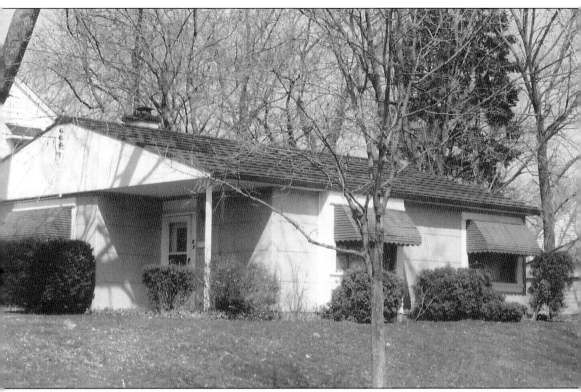

Housing styles range from Victorian Classic and 1920s Georgian to post–World War II bungalows and sprawling ranches. Two unique homes are Lustron houses. Lustrons were the invention of Carl G. Strandlund, who designed and manufactured the prefabricated, all-steel homes in Columbus, Ohio. The homes were manufactured from 1948 to 1951. The home buyer could order the low-maintenance, efficient homes in several colors. It could be assembled in about two weeks. The homes are noted for their built-in features made of enameled steel, including sliding closet doors and counter tops. Bedford's two Lustron homes are at 53 Southwick Drive, shown in the photograph, and 695 McKinley Street. Each home left the factory with a tag that included the model and registration numbers and a reminder to "Call your dealer for service." (Courtesy of Joyce Maruna.)

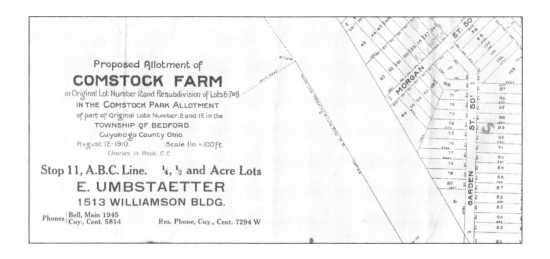

Families in the northern portion of Bedford Township included Fitch, Libby, Wheeler, Raimer, Skeels, Salisbury, Comstock, Parkinson, and Osborn. The 1903 Comstock Park allotment west of Broadway was one of the earliest housing developments in Bedford Township. In 1915, this became part of the newly incorporated village of Maple Heights. A new land development along Libby Road was named the Libby Gardens allotment. It was created by realtors Anthony Marsh and Raymond Hanks from the Raimer homestead. Potential homeowners queue for the purchase of lots in the 1920s photograph. Other Maple Heights neighborhoods included the Greenhurst allotment, Oakland Park allotment, and the Friend Avenue allotment. An advertisement in the 1954 city directory tells of "1000 houses and apartment units being built in the Southgate subdivision."

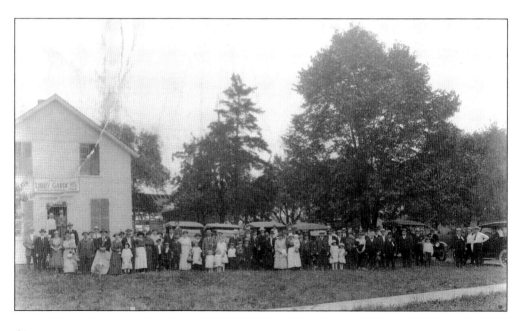

Between 1936 and the early 1960s, local realtor Ludwig Shaner Conelly (pictured) began an extensive residential development, starting with property purchased from the Walton family. Conelly was born in Kingston, Ohio, on August 29, 1883. His heroic efforts as a captain in World War I were chronicled in a book by William Cadwallader titled *Major Conelly's Front Line Fighters*. He was promoted to brigadier general in the National Guard in 1928 and served in the Fiji Islands during the early days of World War II. As a real estate developer, Conelly cut 17 streets in 15 subdivisions in southwest Bedford Township. The photograph below shows Conelly's workers grading a newly cut road. More than 400 houses were built on lots sold by Conelly Realty Company. This became part of the village of Walton Hills on March 20, 1951. Another section of Walton Hills includes Little Egypt, named for a large pyramid-shaped mound. It was a thriving community at the bottom of Button Road along Tinkers Creek in the 1800s. In the 1960s, upper Button Road was transferred to the city of Bedford because of its isolation from the rest of Walton Hills Village.

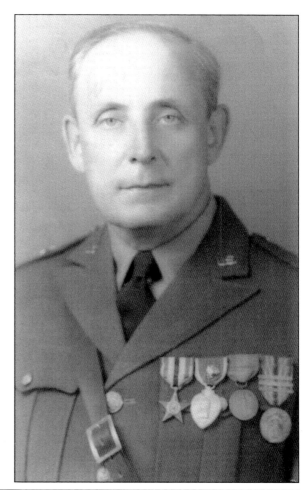

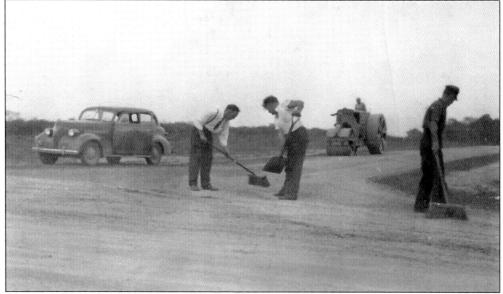

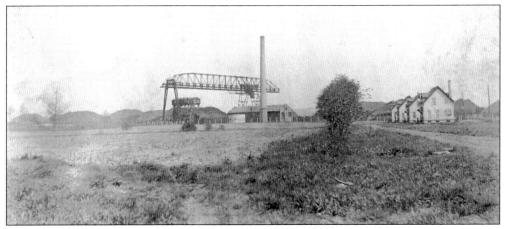

Five Points was a community in the northeast portion of Bedford Township near the intersection of Perkins and Richmond Roads. Many of the men worked at the nearby Erie Railroad Randall Yard, which weighed and stored mountains of ore brought into Cleveland docks. When Lake Erie shipping lanes froze, the mountains of ore kept industries operating.

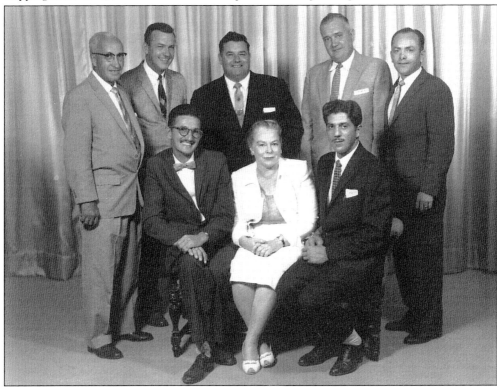

Five Points and northeast land became the village of Bedford Heights, incorporated on February 20, 1951. Robert E. Willeford, the first mayor, and his wife, Georgina, were active in the formation of Bedford Heights. The second mayor, Thomas Ramsay, provided space in his backyard for the village service truck in 1954. Willeford was reelected for several terms. He poses with his administration in this 1960 photograph, featuring, from left to right, (first row) Julius Seliga, Zelma Monahan, and Charles Piro; (second row) Edward Hintz, Lloyd Hunsberger, Mayor Willeford, James Cherosky, and Frank Jaros.

Children in the HOME Nature Club collect trash in this 1974 photograph. Phillip Saunders (pictured) was one of the parents who took the group hiking and camping. Resident Karen Pallat recalls, "When we bought our home in 1970, it was called Rolling Meadows East and was being built by Winslow Homes. Because the area was also originally listed on some plat books as Metropolitan Estates, or Metro Estates, when we started H.O.M.E. Inc., we called it Home Owners of Metro Estates." Other neighborhoods in Bedford Heights included Heather Hill east of Bartlett Road, the Ridge development off Randolph Drive, and the Kimberly Housing development, one of the largest planned residential developments in Ohio. (Courtesy of Robert and Karen Pallat.)

Lincoln Heights developed in southeast Bedford Township in the late 1920s. This area became part of Oakwood Village, the last community to become self-governing. There was lively debate about self-rule. Mrs. Cloyd Kerwin, secretary of the Oakwood Committee, was in favor of forming a village. Residents voted at Frank Dutkas' Hardware on May 1, 1951. The votes were confirmed with 480 *yes* votes to 198 *no* votes. Oakwood remained largely rural into the 1950s. Clevelander Miko Curilovic purchased land on Oakhill Road to build a small barn and cultivate vegetables and fruit trees.

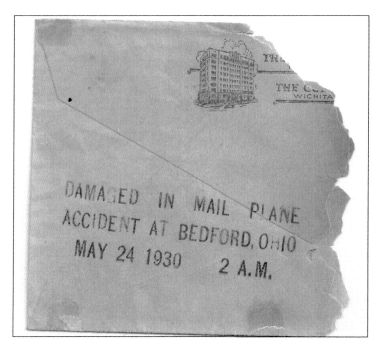

Alonzo Drake's farm had an unexpected visitor on May 24, 1930. Samuel Samson flew the Cleveland–New York night airmail run. On that flight, the engine died at 8,000 feet during a heavy rain squall. Samson tried two nosedives in an effort to start the engine. The *Bedford News Register* quoted the pilot: "The ground was coming up fast so I turned the plane upside down to let the mail bags fall out. Then I stepped out." (Courtesy of Kurt Laubinger.)

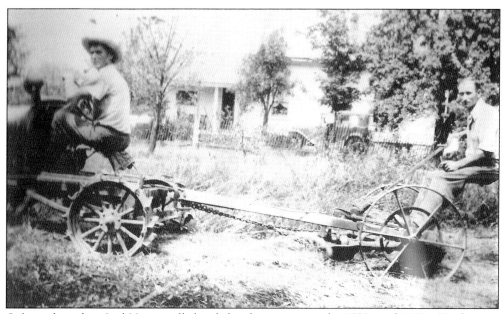

Oakwood resident Lad Vitu recalls local threshing rings in the 1930s and 1940s. He drives a tractor built from a Model T Ford by his father, Anton Vitu, in this 1930s photograph. William Petro, Lad's brother-in-law, sits on the mowing machine. At harvest time, farmers and hired hands worked together. It was the responsibility of the farm wife to feed the hungry workers. A bachelor farmer treated his fellow workers to dinner at a local restaurant called the Pig and Whistle. (Courtesy of Laddy Vitu.)

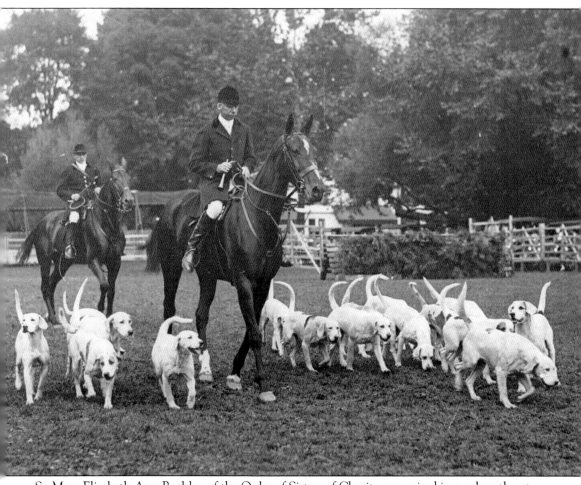

Sr. Mary Elizabeth Ann Rechka, of the Order of Sisters of Charity, was raised in rural southeast Bedford Township. Rechka wrote about a fox hunt hosted by Cyrus Eaton, the millionaire entrepreneur whose estate was nearby. The course crossed the Dilda, Lucas, and Rechka farms. The farmers were notified of a hunt so that precautions could be taken. On one particular hunt, notification was forgotten. Emil Rechka was hunting with his three-year-old son and friend Tommy Exton. They were out some distance when they heard the howling of the hounds and realized that they could not outrun the fox and frenzied hounds. Emil grabbed his son and climbed up a nearby tree. Tommy made it back to the farmhouse, where he and Mrs. Rechka watched. No one was hurt. An apology was issued for the oversight. Sr. Mary Elizabeth Ann Rechka recalled that the hunt club hosted a picnic each summer for the farmers who permitted use of their properties. (Courtesy of Cleveland Public Library, original United Press International photograph used with permission.)

The Village of Crestwood

Crestwood existed only on maps. Resident Earl F. Rogers offered an eloquent speech in favor of the village: "In the American form of government we have a definite road to travel toward self-government—wilderness, township, village and city." Other residents countered that there was an insufficient tax base and residents would have to increase taxes to survive. On January 30, 1950, voters decided. The Crestwood Proposal was defeated 222 to 92.

Gypsies arrived each summer and were permitted to camp behind Durback's Villa, a tavern along Northfield Road. In the 1930s, Joseph Jesensky, a young naturalist and artist, visited the encampment and sketched some of the people living there. Sybella (pictured) was Queen of the camp and nearing 100 years of age. The wanderers felt enough at home to bury their dead in Bedford Cemetery. They return each year to pay homage at the graves.

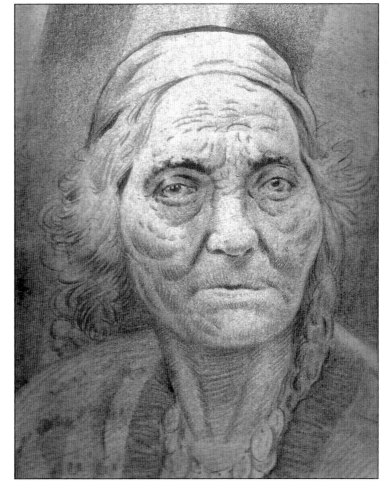

Four

Equal to Any and Excelled by None

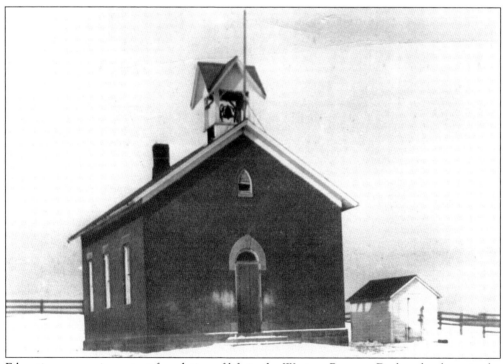

Education was an important foundation of life in the Western Reserve. Drake school was in the Bedford Township Rural School District. The rural district had as many as 12 sub-districts depending on the number and location of children. It was part of District 6 of the Cuyahoga County School District, which also included Bedford Village Public Schools, Maple Heights Public Schools, Glenwillow Village Schools, Warrensville Township Schools, and Bee Hive Public Schools.

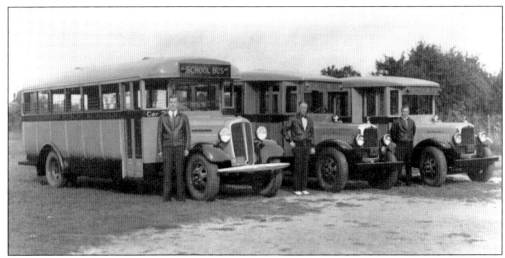

The days of the one-room school were numbered by 1919. County superintendent of schools A. W. Yawberg wrote; "It has been apparent for several years that the one-room school has outlived its usefulness." Rural schools were incorporated into Bedford Village or Maple Heights Village school districts. School bus service started in 1919. Sterling Walton was the first driver. By 1928, three buses were in service to transport students.

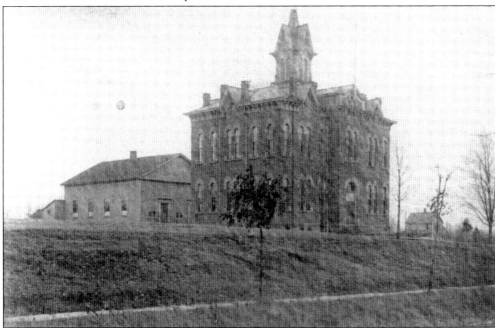

Rural students benefitted from the Boxwell-Patterson law. An article in the January 1906 *Ohio Educational Monthly* explained, "The Boxwell-Patterson law provided for free high school education to all children of the rural districts, children who have so applied themselves to their elementary studies that they can pass successfully the examination prepared and sent out by the state school commissioner." In 1873, construction started for a school on Washington Street at a cost of $15,000. In 1893, the vacant Baptist church on the Square was moved to Washington Street for an additional classroom. After use as a school, the church was moved by blacksmith Jack Strathdee to Woodrow Street for use as his blacksmith shop.

Graduating Class.

Respice finem.

Latin and English Courses,
F. AMELIA HARRINGTON.

Latin Course,
ETTIE M. CONANT.
BENJAMIN J. SAWYER.
O. K. WHEELOCK.

English Course,
HATTIE L. ALEXANDER.

Bedford High School.

First Annual Commencement,

Friday, June 12th,

1885.

The first class graduated from the new school in 1885. Ettie Conant, Hattie Alexander, Amelia Harrington, Odell K. Wheelock, and Ben Sawyer are the five students who received their diplomas. Prior to 1904, a high school diploma was acquired in three years. Beginning in 1905, four years were required, with no graduation class that year. In 1915, manual art training was introduced. In 1916, an electric bandsaw, ripsaw, and jointer were installed with a five-horsepower motor. Graduates could find employment with Bedford's chair companies. Taylor Chair advertised, "Always a few good openings for bright young men."

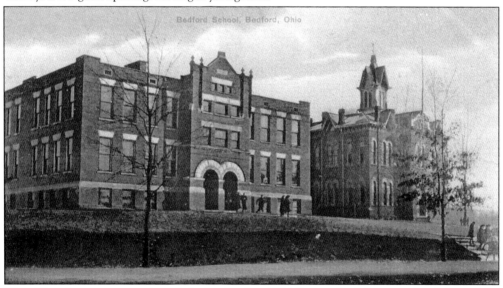

The village began construction of a high school in 1904. Postcards of the new school showed the beautiful building. It served as a high school for about 20 years, then as an elementary school. Many residents recall moving their desks and belongings from the older building to the 1904 school, which was renamed Central School. It remains in use today with additions added to the front and sides. The older portion is visible from the rear playground. Union School was razed in 1952 after sitting empty for many years. According to historian Dick Squire, many architectural details from the old building grace area patios and gardens.

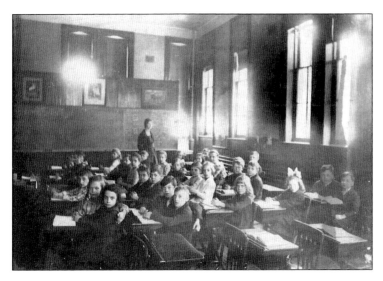

Students at Union School pose for the camera in 1919. Each desk had space for an inkwell. As students developed fine motor skills and better hand-eye coordination, they were introduced to ink and steel stick pens. A blotter, an absorbent pad, was pressed to the page to dry a few lines of script. By the early 1960s, ballpoint pens proved a reliable substitute.

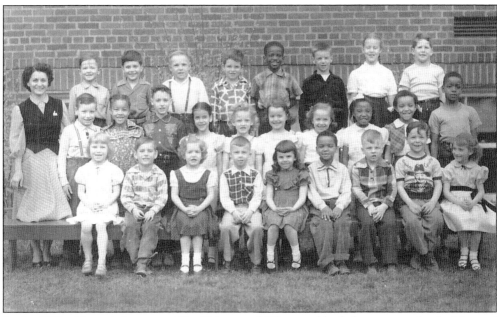

In the 1920s, Central, Interstate, Five Points, and Ellenwood had elementary schools. Many of the students at Interstate School learned English as a second language. Their families emigrated from Eastern European countries to work in the massive industrial McMyler Interstate Company plant. Superintendent Dr. Anson E. Moody reported in 1921, "Special efforts were made by the teachers all year to instill a love of America in the children of immigrants." In 1921, a night school was offered to adult foreigners to assist them in obtaining citizenship. Interstate School students in the 1950s pose with their teacher. The school was closed after the 1964–1965 school year.

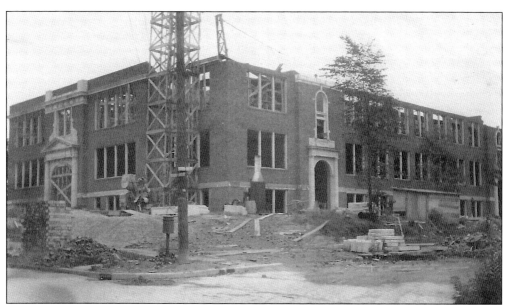

The third Bedford High School was on the corner of Columbus Road and Washington Street. H.R.P. Hamilton, a Cleveland architect, designed the new school. Principal Warren Miller recalled in an interview that the building was designed to serve the public. The main entrance opened onto a lobby and auditorium. It was home to the Bedford Library until 1940. The cornerstone-laying ceremony was held on Mother's Day, May 8, 1921. A copper box used as a time capsule was made by local metal smith William E. Lambert. Some of the contents included school rosters and newspaper articles about the construction. The above photograph shows the building nearing completion. Bedford High School finished its life as Moody Junior High from 1959 until 1982. It was a sad day when the beloved old building fell to the wrecking ball.

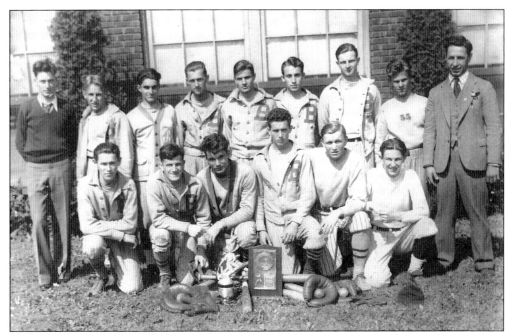

Bedford sports united the whole community. A combination of great coaching and top athletes resulted in several championships. Sam Hott (far right) poses with the 1931 baseball team, which includes, from left to right, (first row) unidentified, Al Axford, Alex Sylvestro, unidentified, Jim ?, and Ed Garvey; (second row) unidentified, Harry Yorkovitz, Al Romito, unidentified, Emil Fogoros, Hugo Cipriani, Hardy Garvey, and Mike Shantic. Hott was with the system from 1928 to the 1960–1961 season. Woodrow Shipley continued with winning teams. James Rose was named coach of the year nine times in the Greater Cleveland Conference with eight league championships over his 16-year career.

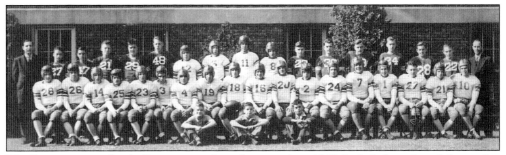

The Bearcat varsity football team poses for a photograph in 1943. Included are, from left to right, (first row) young admirers William Albrecht, Clair Lewis, and Thomas Flaisig; (second row) Nick Durback, John Biltz, William Gorenc, Norm Pallotta, Ed Grudowski, Dick Martin, Bill Carano, Bernie Troutman, Bernie Rickleman, Don Webster, Bill Wingerter, Bob Began, Art DePompei, Jim Fritzsche, Dick Rickleman, Bob Oldroyd, Bob Sablotny, and Dick Bell; (third row) coach Woodrow Shipley, Don Karpinski, Don Heaston, Bill Marshall, Al Pankratz, Ted Dengate, Bob Keary, Frank Duale, Bill Sykes, George Matcho, Bill Dawson, Bob Chapin, Jack Galloway, Bill Martin, Bob Chaney, Roger Waterbury, and coach Archie Davis.

Pictured from left to right, teammates George Pistotnik, Tom Rickleman, Bob Waterson, Dale Jones, and Arvid Johnson watch Gilbert Grooms practice a jump shot in 1950. Grooms was voted all-conference two years, most valuable player as a junior, and was a high scorer on the team.

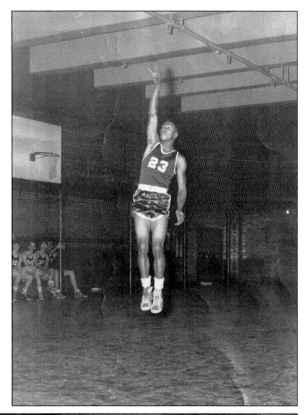

Nancy Gauldin McRitchie recalls cheerleading tryouts were held in the spring, and practice was all summer. Fundraisers helped buy uniforms and pay for an injury fund. McRitchie's 1953 squad celebrated the 10th anniversary of Bedford High cheerleading. In the early years, the Rooter's Club, which formed in 1919, encouraged students to cheer at games. From left to right in this 1951 photograph, Sally Tench, Dorothy "Dot" Patterson, Nicolina "Nickie" DePompei, and Eleanor "Ellie" Bohland practice in the gym.

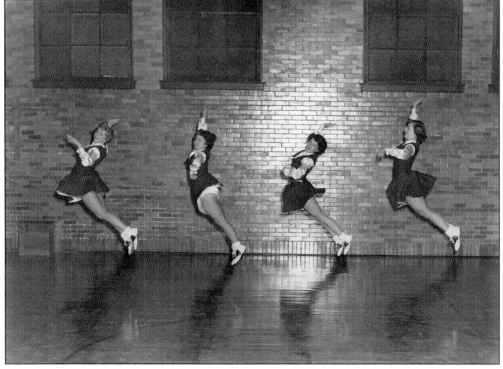

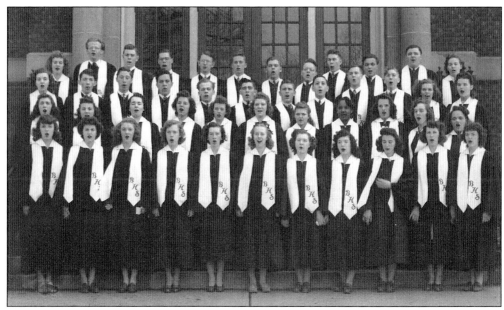

Gertrude A. DeBats was a popular music teacher from the late 1920s until her retirement in 1966. The photograph shows the 1944 a cappella choir. Graduates of Bedford High School formed an alumni chorus, which is credited with being the first organized in the United States.

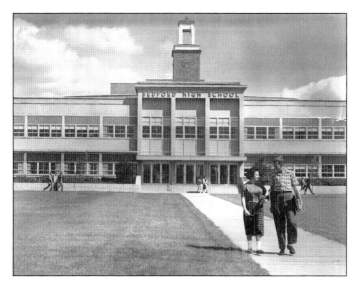

The fourth and current Bedford High School at 481 Northfield Road was dedicated in February 1959. Over 1,000 people attended the dedication. Dr. Lewis E. Harris, of the Ohio School Boards Association, was the keynote speaker. The main building was used as a junior high for a few years prior to the high school. The class of 1961 attended both junior and high school in the new building. The property was the location of athletic events at Stewart Field.

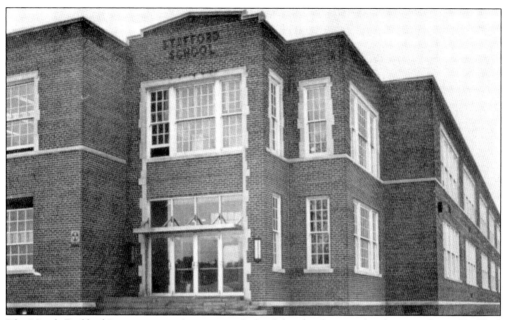

The North Bedford Improvement Association helped develop better schools in northwest Bedford Township, which became Maple Heights. Through their efforts, a four-room school was erected on Broadway at Lee Road. From 1920 to 1923, the population in Maple Heights doubled to 3,000. Stafford school, shown here, opened in 1930. At its highest population, the system operated six elementary schools: Granger, Broadway, Dunham, Rockside, Stafford, and Raymond. It had two junior high schools—East Junior High and West Junior High—which merged in 1981 to form Maple Heights Junior High School.

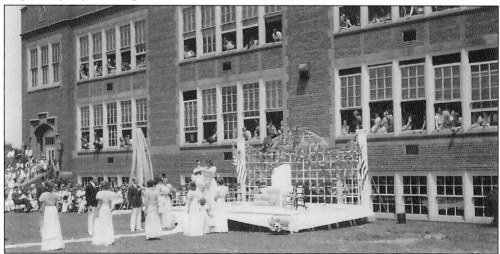

Prior to 1924, Maple Heights students who wanted to attend high school were required to take the Boxwell-Patterson exam, the same as Bedford rural school students. In 1924, a total of 45 students began high school studies in the Maple Heights school system. The students moved to several locations, including the town hall and the top floor at Broadway School. The 1925 Clement Drive Elementary building was chosen, and a large addition was added. The new high school opened in 1931. The photograph shows the crowning of the May Queen on May 26, 1939, near the main entrance. (Courtesy of John Straka.)

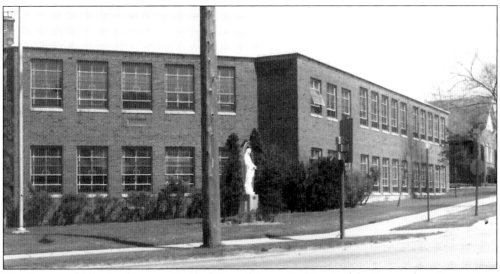

The first parochial school to serve Bedford Township was St. Mary's of the Immaculate Conception. As the Roman Catholic population increased, a larger school and church were built facing Northfield Road. When a separate church was constructed on Union Street in 1969, the old sanctuary was converted into a gymnasium-hall with a kitchen at one end.

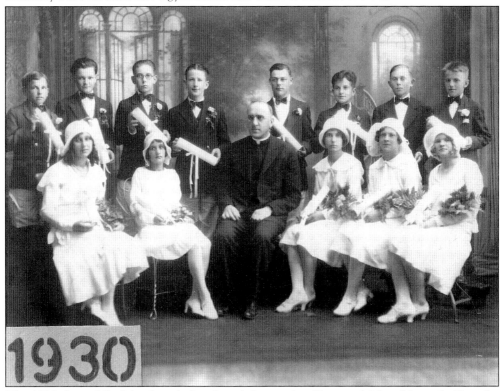

The 1930 class of St. Mary's includes, from left to right, (first row) Mary Horvath, Dorothy Karpinski, Fr. George Stuber, Nellie Krempa, Agnes Vincent, unidentified, and Henrietta Pund; (second row) Emil Biros, unidentified, Maurice Weber, Arnold Schulte, Joseph (or George) Paluscak, unidentified, Andrew Dzubak, and Francis Drabik. (Courtesy of Paul E. Pojman.)

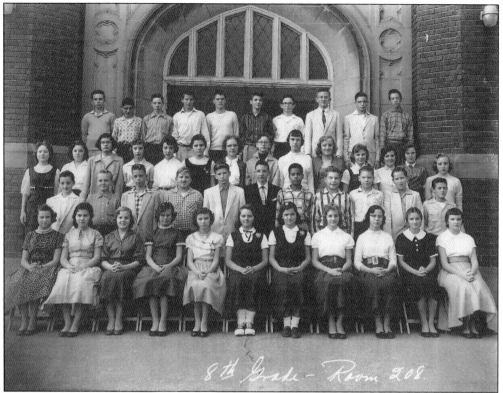

St. Wenceslas parish opened a school in 1926. The brick building with an auditorium provided classroom space for the 84 students who enrolled the first year. Mass was celebrated at a chapel, which was the former Libby Gardens, a dance hall along Libby Road at Cato Avenue. In 1951, the auditorium was remodeled into a large sanctuary, and a convent was constructed. Decreasing enrollment resulted in closure of the school in June 2004. The 1957 eighth-grade graduating class poses in front of the original entrance in this photograph. (Courtesy of Helen Varga Hurtuk.)

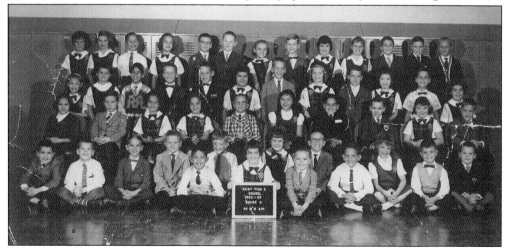

St. Pius X School at 400 Center Road opened as an elementary school as part of the St. Peter Chanel High School project. The photograph shows Sr. Mary Barbara Ann's second-grade class with 49 children. (Courtesy of Christine Strnad Walker.)

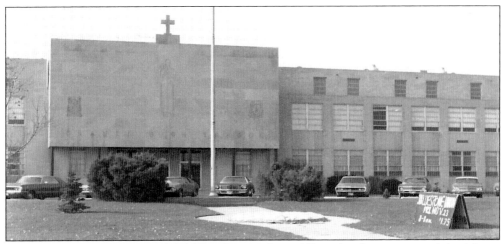

St. Peter Chanel at 480 Northfield Road opened in 1957 under the auspices of the Marist Brothers on 33 acres donated by archbishop Edward F. Hoban. Stickle and Associates designed the high school that was named after Fr. Peter Chanel, a Marist missionary killed in Futuna, an island in the South Seas. The school soon developed an excellent reputation as a Catholic boys' high school. The first freshmen entered in 1957 and graduated on June 4, 1961. Chanel High School became coeducational beginning with the 1986–1987 school year. Chanel won several state championships: wrestling in 1983, 1986, 1987, 1988, and 2011; football in 2001; and boys' basketball in 1999.

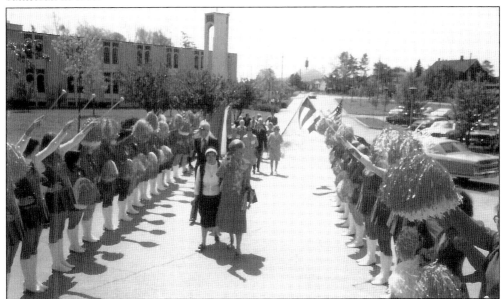

Lumen Cordium High School for girls opened in September 1963 with an enrollment of 42. It was the idea of Sr. Mary John Berchmans, the first general superior of the Vincentian Sisters of Charity. She did not live to see the school become a reality; her successor, Mother Mary Joseph, oversaw the project. The first classes met in the convent retreat house on Broadway. Ground was broken at the corner of Union Street and Northfield Road in November 1963 for a modern, three-story school designed by John F. Lipaj and Associates, who had recently completed the new Bedford City Hall. Declining enrollment and escalating costs resulted in closure in 1986. In the photograph, the duke and duchess of Bedford, England, receive a warm welcome during their 1976 visit.

Five

THE LITTLE CHURCH WITH THE BIG HEART

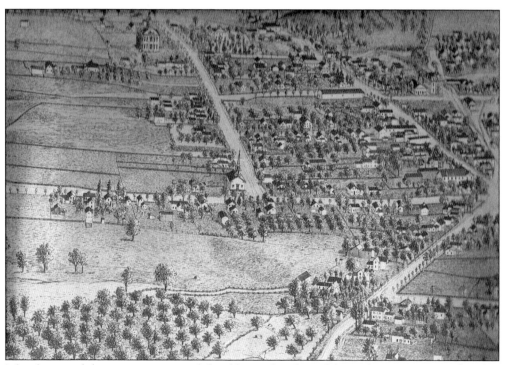

It has been said that a community is defined by its churches, clubs, and organizations. Churches have been an important part of the life of Bedford Township, and this chapter discusses some of them. The early lithograph shows three church steeples in 1885: Methodist, Disciples of Christ, and Baptist.

Methodists organized in 1830. Fanny Willis donated a frame building for use in 1849 with the stipulation that it be moved. It was moved onto the southeast corner of Columbus Road and Washington Street. In 1886, the congregation built the Centenary Methodist Church, designed by local architect Frank D. Marble, on the corner of Main and North Streets. The sanctuary is shown in the photograph. Bedford High School used the church for graduation services in the late 1890s. Methodists used the building until 1926. Herman Maurer designed the current Gothic-style church located at 79 Center Road, which opened in 1928. Interior windows are from the Centenary church.

The Disciples of Christ Church, later known as the Bedford Christian Church, was organized in 1832. It also benefited from Fanny Willis, who had built a church on the east side of Broadway in 1838. An interurban car passes by the church in the 1909 photograph. In 1924, the congregation moved to a new brick building at the corner of North Street and Blaine Avenue. The pulpit where James A. Garfield preached was moved to the new church. The congregation declined until the church closed in 2007.

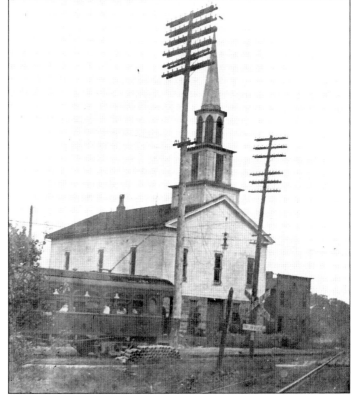

Andrew Hensey, a member of the Disciples of Christ Church, was one of several missionaries from Bedford Township. Hensey translated the New Testament into Congolese dialects. He was twice decorated by the King of Belgium for his efforts. Other missionaries from Bedford included Lillian Collins, who served in China in the early 1900s. Grace Nichols taught in India during that same period, as did Mr. and Mrs. E.O. Davis. J.O. Beardsley served in Jamaica. Kate Ellet and her husband, Joseph Samuel Murrow, worked among American Indians on Western tribal lands.

The Presbyterians built a meetinghouse in 1861 a few yards north of the Disciple Church on Main Street. Members had been meeting in various locations prior to that. The Wooster Presbytery supplied clergy. Early pastors also served a church in Northfield Ohio. By 1885, the congregation no longer had a presence in Bedford. Some of the members followed the Reverend William Hamilton to the church in Northfield, Ohio. Maple Heights Presbyterian formed in the northern end of the township. The empty building was used as a feed and grain store, as shown in the image below.

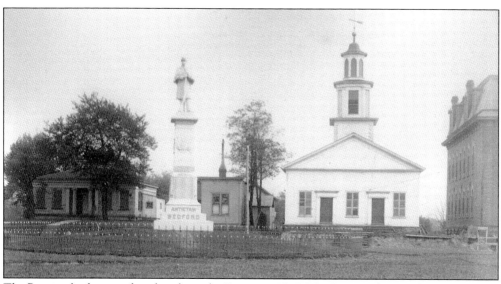

The Baptists built a wooden church on the Square in 1840. The Reverend Samuel Willard, father of artist Archibald Willard, was the first minister. The bell in the steeple was purchased and owned by the residents of Bedford for use in emergencies. The 1,000-pound bell was cast in Troy, New York, by the Meneely Bell Foundry; it had an extra measure of silver so that the ring would be harmonious. The church purchased Dr. Hubbard's property next door and hired Akron architect Jacob Snyder to build a larger church, which opened in 1892. The stone home, originally known as the Widow Smith's house, was dismantled, but the wooden building that was Dr. Hubbard's office was moved to Washington Street where it is a home today. The bell was moved into the tower of the new church at 750 Broadway. About four months after it was installed, it was rung for hours to sound the alarm when the business district burned on September 7, 1893. A Moller pipe organ was installed in 1914. It was paid for in part by a grant from philanthropist Andrew Carnegie. The Baptists held several fundraisers to earn money for the organ. Members make apple butter outside the church.

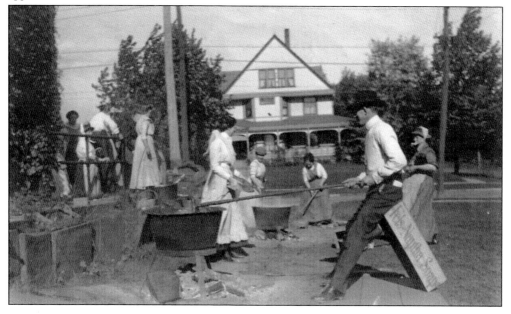

In the early 1920s, a group of residents met in the Lincoln Heights area of Bedford Township. The Reverend Gainey Washington, a traveling deacon from St. James AME Church in Cleveland, ministered to the group. By 1923, the congregation purchased land on Lincolnville Avenue and built Bethel AME Church, also known as Lincolnville AME Church. In 1948, Cleaster Fowler took this photograph of the congregation on the steps of their new building renamed New Bethel AME Church. Member Dorothy Evans called it "the little church with the big heart."

Mt. Moriah AME Church at 5620 Lafayette Avenue in Maple Heights was founded in 1926 to serve residents in the Maple Heights area. Mr. and Mrs. James Sands opened their home for prayer meetings; this became the seed for Mt. Moriah. Monroe Colley, another founding member, was instrumental in developing the Sunday school program. The original building was a wood frame structure. It was removed to build a larger facility in the 1930s. Members dug the foundation by hand then built the new foundation using stones salvaged from razed mansions that stood along Euclid Avenue in Cleveland.

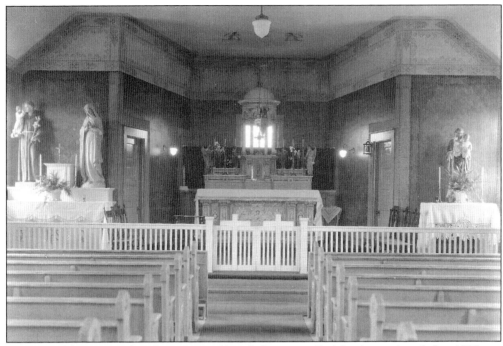

St. Mary of the Immaculate Conception Church, known as St. Mary's, was founded in 1905 as a mission church of Holy Name parish in Newburg. The congregation initially celebrated Mass in the Shannon house; then they rented the town hall for $1 a week. The Schneider family, owners of Best Foundry, donated $500 and a portion of their estate at Union and Paul Streets. A brick building that contained a sanctuary and classroom was erected in 1909. When Paul Schneider died in 1909, the estate was purchased by real estate developer Bernard Schatzinger, who donated it to the diocese. The property was named Villa San Bernardo, and a statue of St. Bernard was erected in Schatzinger's honor. In 1921, it became a parish. Fr. John R. Hagan was the first resident pastor. St. Mary's closed in 2009 when local parishes merged.

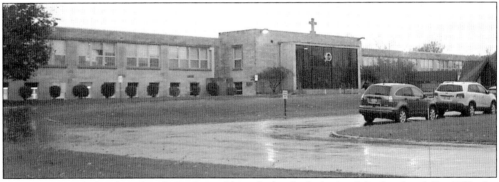

St. Pius X parish developed with St. Peter Chanel, the Catholic boy's high school. By 1952, the new parish served 700 families. Mass was held in Stafford Elementary School for Maple Heights parishioners and at the Bedford and Stillwell theaters for Bedford parishioners. The rectory was at 37 Avalon Avenue in Bedford. As population decreased in the area, the Cleveland diocese merged the congregations of St. Mary's, St. Pius, and Holy Trinity in Bedford Heights. St. Pius Church property was chosen by the bishop as the location for the combined congregation. The new congregation celebrated the first Mass on November 22, 2009, united as one parish known as Our Lady of Hope.

St. Mary's Russian Orthodox Church, originally Greek Orthodox, was established in 1927 at 37 Charles Street. It served the orthodox community for over 40 years. The last service was held on October 26, 1968, when it merged with St. Andrew Eastern Orthodox Church in Maple Heights, which broke ground in 1967. Fr. John Lembara, the new pastor, led a procession from St. Mary's Orthodox to St. Andrew with holy articles and *plaschanitza*, a winding cloth representing the dying Christ. Photographer Chris Christenson took the photograph in the 1960s.

Families from the northwest area of Bedford Township formed Zion Lutheran in 1883. Members met in a former school building on Dunham Road. These founding members originally were part of St. John Lutheran Church in Garfield Heights. As the congregation grew, an addition was added to the school building. In 1891, the congregation built a new wooden church, which was moved in the early 1960s to Rockside and Dunham Roads.

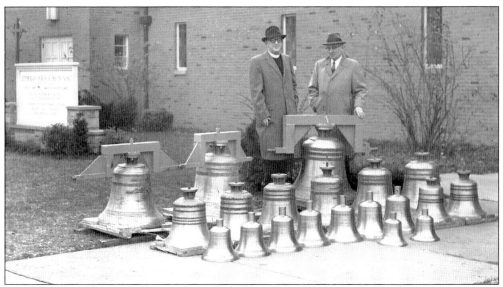

Lutheran Church of the Covenant at 19000 Libby Road started as an outreach church from St. Andrew Evangelical Lutheran Church in the Miles Park area of Cleveland. Parishioners living in Maple Heights formed Trinity Lutheran Church under the guidance of Rev. Richard P. Oehlschlaeger. The two churches merged to form Lutheran Church of the Covenant. Architect J. Adam Fichter designed a new church, which was dedicated on December 2, 1951, in the style of 13th-century Norman architecture. A carillon tower was dedicated 10 years later with 25 bells manufactured in the Netherlands. The photograph shows the bells being prepared for installation. (Courtesy of Lutheran Church of the Covenant.)

The Evangelical Lutheran Church of the Master was organized on May 11, 1958. The young congregation met at Carylwood School, then the Masonic hall, and at a small church located at 24 East Grace Street. Property for a new building was purchased along Northfield Road near Solon Road. Cleveland architects Herk Visnapuu and Robert Gaede designed the new edifice, which was dedicated on June 24, 1962. The church expanded with an addition in 1978. (Courtesy of Lutheran Church of the Master.)

Six
Yourself and Lady Are Cordially Invited

As population and interests changed, so did social institutions. The Bedford Masonic Lodge No. 375 Free and Accepted Masons received dispensation on October 14, 1866. Bedford Lodge No. 375 contributed $1,500 toward the building of the Bedford Township Town Hall in 1874. The third floor was owned and maintained by the lodge; this set the precedent for condominium laws used today. The invitation reads, in part, "Yourself and Lady are cordially invited."

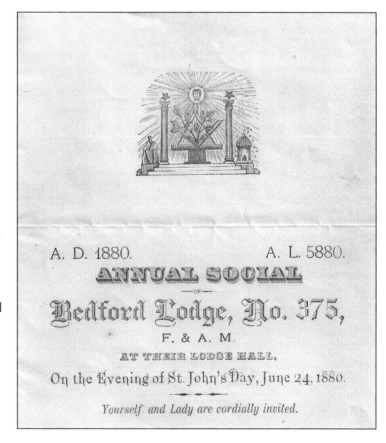

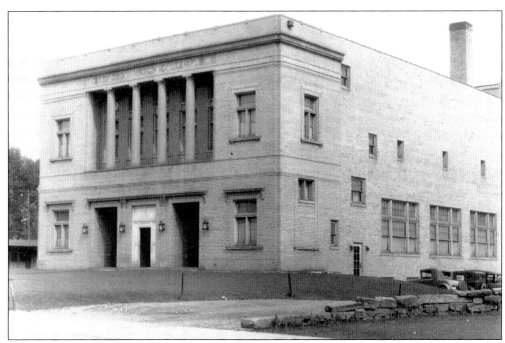

Other Masonic organizations included Summit Lodge No. 74 Royal Arch Masons, DeMolay International, the Order of the Eastern Star, and Rainbow Girls. In 1918, the Temple Company was formed to raise funds for a larger hall. Architect Randall F. Medicus designed a building at 38 Tarbell Avenue. On July 17, 1927, the cornerstone was placed, including a time capsule. It was dedicated on March 4, 1928.

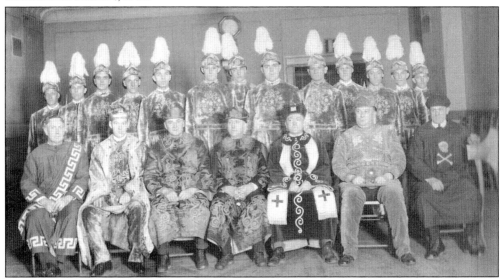

After the Masons moved, the Town Hall's third floor was deeded to the Junior Order of the United American Mechanics Society (JOUAMS), an organization concerned about the influx of immigrants. Then the Knights of Pythias, seen in the photograph, used the hall. The Knights of Pythias was founded in 1864 by Justus H. Rathbone in an effort to build the bonds of friendship after the hatred of the Civil War. The Bedford lodge, known as Goldenrod No. 467, held many popular programs for the public.

The Anti-Saloon League, which led efforts to ban the use of alcohol in public places, was one of the more controversial organizations 100 years ago. This poster caused a controversy in town. It was written anonymously by Albert V. Taylor, son of Vincent Taylor, the president of Taylor Chair Company. Albert served two terms as mayor of Bedford and was the treasurer of the family business. In an effort to gain votes, he distributed the flyer without authorization from the Republican Party. The party was quick to apologize and exposed the controversial writer and his habit of drinking alcohol. On May 18, 1907, Albert Taylor's body was discovered along the Pennsylvania Railroad tracks in Bedford. It remains a mystery to this day whether his death was an accident or murder.

Danger!

The effort to re-establish saloons in Bedford puts

Your Home in Peril.

In company with all citizens you are invited to attend a mass meeting in the

Town Hall
Sun., Feb. 12, '05
7 P. M.

Rev. R. M. Freshwater, D. D. of Cleveland will speak.

Mr. O. K. Wheelock will preside.
Music by the Bedford Orchestra.

An Easy Question

Which is the more important, the happiness of two thousand men, women and children, or the pocket-books of a few blood-sucking saloon keepers?

TO THE VOTERS
OF
BEDFORD VILLAGE.

A Reply to the Last Sob of a. v. taylor, Entitled:

A REWARD
FOR
BEING WET

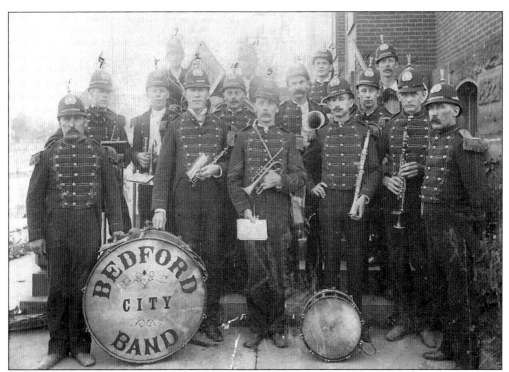

The Bedford Band poses in uniform on the steps of the town hall. The 1890 photograph lists the last names of the members as, from left to right, Golling, Stafford, Necker, Lee, Flick, Laing, Scott, Lockwood, Golling, and Lee.

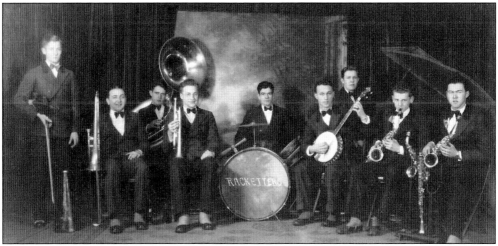

According to Margery Balder Thiele, "Bedford High School graduates and some seniors formed this dance band in 1929, the 'Racketters.' They played for many dances at the high school as well as for various fraternal organizations of the city that would hold dances for their members." In the photograph are, from left to right, John Smith, Carroll Wolcott, Earl Skillicorn, Chester Shipherd, Glenn Maley, George Taylor, Robert Dawson, Wilbur Janda, and Kermit Balder. (Courtesy of Margery Balder Thiele.)

The Bedford Garden Club, initially proposed as the Bedford Gardening Association, was founded in 1927 by invitation to selected residents. Through the club's efforts and expense, gardens were installed at public places, such as Bedford Cemetery and the garden at the Town Hall Museum. It helped Bedford to be named as a registered bird sanctuary and a Tree City USA. It lobbied for ordinances to control roaming dogs. During World War II, it helped with a Victory Garden on North Street.

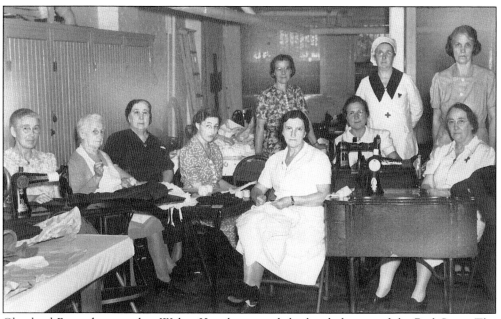

Cleveland Press photographer Walter Kneal captured the local chapter of the Red Cross. The members are stitching items during a meeting in 1941. Kneal spent the day in Bedford recording the daily activities of residents.

During the Civil War, 208 Bedford Township men served in the Union army. The Grand Army of the Republic (GAR) was a service organization founded by Benjamin Stephenson in Decatur, Illinois, in 1866 to help widows and orphans of Union soldiers. Through its efforts, May 30 was designated Memorial Day. The Bedford GAR raised funds to erect the Civil War Monument on Bedford Public Square. In this photograph, aging Bedford veterans view the Soldiers and Sailors Monument erected on Cleveland Public Square in 1910.

American Veterans (AMVETS) raised funds for an iron lung in the 1950s. People stricken with a severe case of polio required the apparatus to breathe. AMVETS was one of several Bedford Township veterans' organizations that helped veterans and many other causes in township communities.

Spectators wait for the Memorial Day Parade in 1948. The Memorial Day parade and ceremony at Bedford Cemetery has remained much the same since it began with members of the GAR after the Civil War. Over the years, it has been refined with guidance from several veterans, including Vito Donofrio, George Lambert, and Ralph Bell Sr., under the auspices of the Bedford Joint Veterans Council. Donofrio was general chairman from 1960 to 1988. Bedford High School marching band and majorettes march through town during the Memorial Day parade in 1953. Traffic was maintained along Broadway; today, the street is closed during the parade. (Courtesy of Helen Pfenninger Batko.)

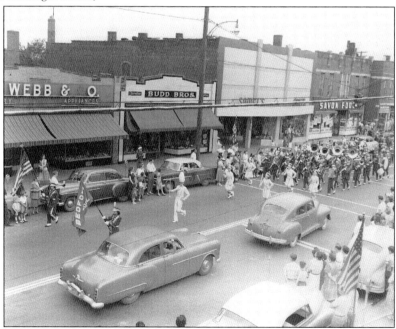

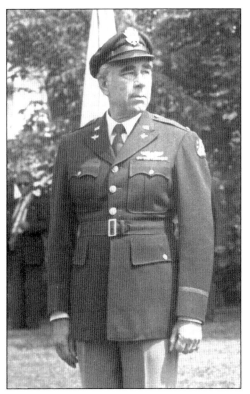

James Fiedler, born in Everett, Ohio, was commander of troops for over 30 years. He joined the Army Air Force in 1943, at 18 years of age, and was a navigator on B-17s, C-46s, and C-47s in the Pacific. He earned the rank of first lieutenant. Upon conclusion of his military duties in 1948, he was hired by Lynn Horton, who owned Horton Chevrolet in Bedford. He eventually coowned Lally-Fiedler Chevrolet. Fiedler and his wife, Rena, were active in several community organizations. (Courtesy of James Fiedler.)

Maj. Robert Brown served in the Army Air Corps during World War II in the 61st Troop Carrier Squadron of the Ninth Air Force. After the war, he helped his brother William in the real estate business. For a time, he and his wife owned a construction company. Brown flew on weekends for the Army Air Reserves and resumed a fulltime position on base during the Cold War. He was responsible for disaster preparedness and Civil Defense training for the region. (Courtesy of Mrs. Robert L. Brown.)

Dr. L.M. English is mounted on Dolly, a horse owned by John A. Burns, for the homecoming parade. Dr. English was a local dentist in Bedford who coached the Bedford High School football team and organized five Boy Scout troops. Dr. English was serving as mayor of Bedford at the outbreak of World War I. He resigned and joined the Army. Mrs. English joined the Red Cross and served in France during the war.

This clever invitation announces a meeting of the Ben Johnson Club, a men's club founded in 1932 by Ralph Bell Sr. to discuss a pertinent topic of the day. The last recorded meeting was April 1, 1976. Several book clubs and discussion groups remain in the area. The Friday Study Club, founded in 1937 by local women, was limited to 16 members. It also discussed a pertinent topic of the day. It continues to meet in members' homes with a new member admitted only when someone retires.

The Ground Observer Corps was formed during World War II to protect the US border with a series of outposts operated by civilian volunteers. The Bedford Outpost, which formed in the summer of 1950, was named Juliet Mike 22 Red. A small tower was built on Northfield Road near the athletic fields of Bedford School District. In 1956, it was replaced with a larger steel tower. By 1953, the post had 24-hour coverage by dedicated volunteers. Every aircraft in range was recorded with its estimated altitude and direction. Suspicious aircraft were reported to the Canton Filter Center.

When radar—a new, sophisticated technology at the time—became standard, the Air Force deactivated the corps in Bedford in 1959. The Civil Defense truck was given to Bedford Fire Department by the Ohio Civil Defense Corp in the 1950s. (Courtesy of Lynn Jones.)

The Bedford Kiwanis was founded in 1949 and served the community until 1999. The club sponsored an annual student art show and pancake breakfast each spring. Stuart Henderson, in the center, was the pancake "chef supreme" for Kiwanis. In the photograph, he is assisted by John "Jack" Wise, on the left, and Donald Flagg.

Bedford Rotary was established in 1926. The organization was made up of business and professional men in the area. Rotarians raised funds for a Bedford Hospital expansion project in 1982. William Pollack, hospital superintendent, receives a check from Rotarians, including, from left to right, Daniel Sutherin, Peter Junkin, Sterling Spaulding, Ralph Bell Sr., Jerry Blau, and Stephen Radecky.

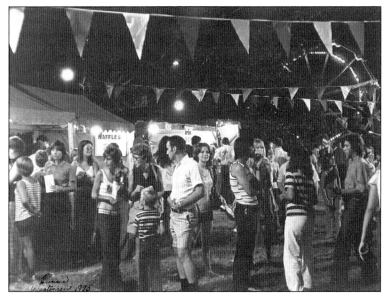

The Bedford Lions was chartered in 1927. The club supplied food baskets to the needy, sponsored athletic events for youth, and supported local organizations, such as Boy and Girl Scouts and the YMCA. The Bedford Lions has sponsored a yearly carnival since 1930. This photograph shows the 1975 carnival.

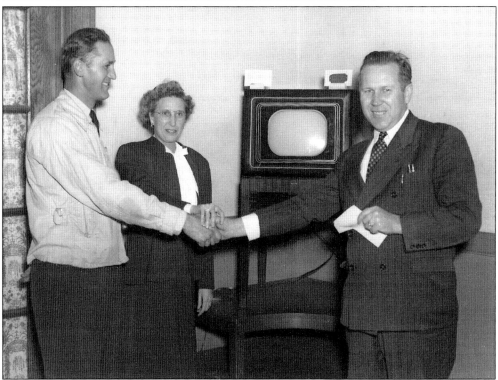

The Fraternal Order of Eagles (FOE) was founded in 1898 by six theater owners in Seattle, Washington. Local chapters, known as Aeries, support many community projects while offering good fellowship for its members. The Bedford chapter, Metropolitan Aerie 2122, received its charter on October 7, 1930. The women's auxiliary was formed in 1939. Slagle's Studio took this 1949 photograph of Vernon L. Gottschalk (YMCA secretary, at left), Catherine C. Loomis (Bedford Civic Round Table secretary), and Stephen Szaraz (chairman of the Eagles television campaign committee). (Courtesy of FOE Metropolitan Aerie 2122.)

The Soap Box Derby was an important part of community life, especially in the 1940s and 1950s. The race was run on the new section of Broadway southwest of Tinkers Creek. Racers speed down the new curve on Broadway in the photograph. The winner raced in Akron at the annual Soap Box Derby.

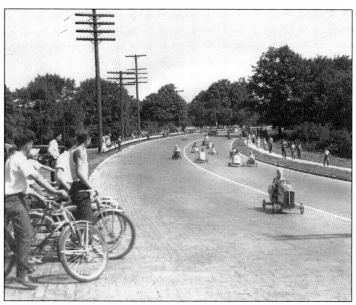

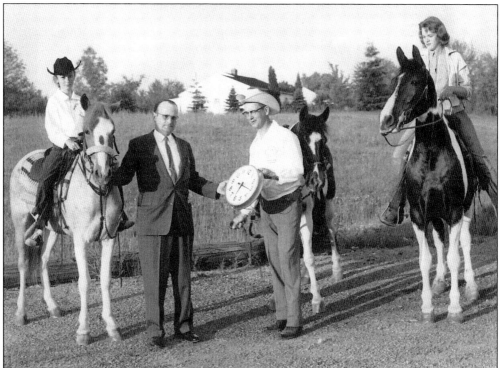

Mayor Thomas Young, standing left, accepts a clock for the downstairs meeting room in the Village Hall, a gift from the Walton Hills Rangers. The equestrians are Kathy Mills (left) and Sandy Mathieson. Rangers' president Malcolm "Mac" Mills stands with the mayor in this 1960s photograph. Horseback riding, particularly in Walton Hills, was a popular pastime. The Walton Hills Rangers, an equestrian club organized in 1957, sponsored many activities and horse shows. Riding academies in the area included Black Beauty Riding Academy on Dunham Road and Emerald Circle Riding Academy on Button Road.

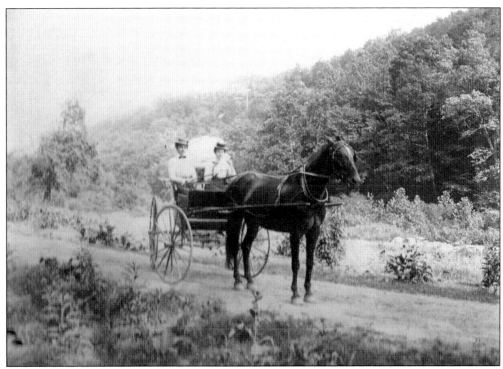

Not all social activities centered on churches, clubs, and cultural events. Frances Black (right) and sister Ida LaRue, known as "Lu," enjoy a ride through rural Bedford Township in July 1913. Both sisters were graduates of Bedford High School 1897 and 1903 respectively. The girls were raised on a farm in the southwest portion of the township known as Egypt. Frances lived a bold life. She once skated on the Ohio and Erie Canal from Bedford Township to Cleveland.

In the 1950s, Bedford resident Vera Faragher took flying lessons from Walter Vance at Sportsman's Aviation Center in Northfield, Ohio. After her lesson, she crossed the field to work in the ticket booth at Sportsman's Park, an automobile racing track.

Seven
ALWAYS A GOOD SHOW

Fairs were popular social events in rural communities, and Bedford hosted large ones in the mid-1800s. Early maps indicate a fairground was located along Columbus Road west of Northfield Road. The Agricultural, Mechanical, and Industrial Society sponsored the fairs, and several communities were represented. When the fair outgrew the location in Bedford, other communities hosted the event until property in Berea, Ohio, became the permanent location. The Cuyahoga County Fair, as it is known today, attracts thousands of visitors.

LIST OF PREMIUMS AND REGULATIONS
FOR THE
SEVENTH ANNUAL FAIR
OF THE
BEDFORD UNION
Agricultural, Mechanical & Industrial Society
[EMBRACING THE TOWNSHIPS OF BEDFORD, SOLON, WARRENS-
VILLE, NEWBURGH, INDEPENDENCE, NORTHFIELD,
ORANGE AND CHAGRIN FALLS ;]

TO BE HELD AT

BEDFORD, OHIO,

ON TUESDAY, WEDNESDAY & THURSDAY,

OCTOBER 5TH, 6TH AND 7TH, 1864.

CLEVELAND, OHIO:
MORNING LEADER STEAM PRINTING ESTABLISHMENT—E. COWLES & CO.
1864.

The Bedford Glens recreation area was owned by the Gould family in the 1800s. It was located near the center of the village above the great gorge created by Tinkers Creek. People could picnic, camp, play carnival games, skate, and hike. In 1900, Evan Day assumed operation of the pavilion. It was used as a roller-skating rink, but Day saw the popularity of ballroom dancing and converted the building into a beautiful ballroom. Evan's nephew Ed supplied first-class dancing music with his band Ed Day and His Ten Knights. Radio station WHK broadcast two three-hour programs from the Glens. Ed Day became known as "the Waltz King of Ohio." In the 1930s, Bedford High School used the Glens Ballroom for commencement.

In the late 1930s, ballroom dancing lost popularity, and the floor was returned to a roller-skating rink with a bowling alley in the basement. There were still places to picnic on the grounds with carnival booths offering fun games. On April 18, 1944, the Bedford Glens Pavilion suffered a devastating fire. Patrons quickly evacuated the building with no loss of life. At the time, 15-year-old Marge Miavitz was skating with her friend Martha Jackowski. She recalled, "It was early and we were practicing the flea hop in the Rose Room when we began to notice smoke coming from downstairs." The Bedford Glens did not rebuild, but it remained a wonderful memory for thousands of people.

In the early 1920s, a dog-racing track straddling the Cuyahoga and Summit County line was constructed. It was known as the Euclid Kennel Club. The facility had plans for pari-mutuel betting. Wagering would take place in the county that was first to approve a gambling referendum. The track had contentious issues on both sides of the county line; trade unions from both counties demanded employment for their members. But Cuyahoga and Summit were united on one issue: no gambling. The track closed.

In 1936, a police officer named John A. McNeal developed the track for racing midget-size cars, including those powered by Kurtis-Kraft Offenhauser engines. The track was called Sportsman's Park. McNeal's efforts were not entirely successful because of terrible weather, and the track closed. Don Zeiter, a successful promoter of the Detroit Motor City Speedway, reopened the park with more success and operated it until 1949 when the Clay family purchased the track. They offered stock car racing. Eventually, the midgets were phased out.

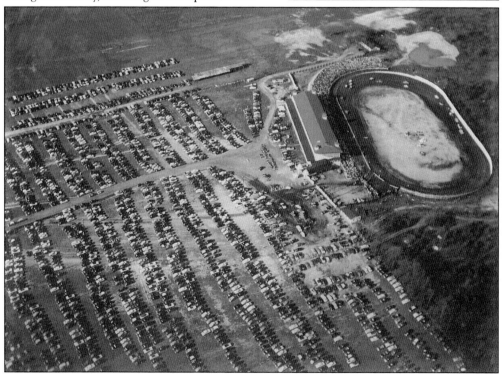

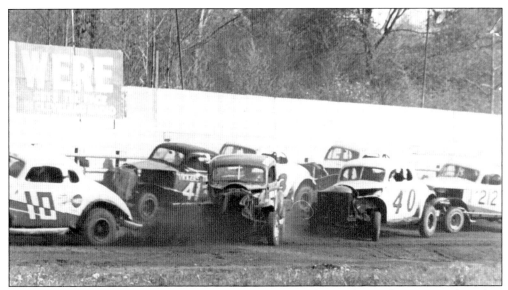

Trackside photographer Andrew P. Jones captured this pileup. The track was open from late spring to Labor Day. Successful drivers were rewarded with cash, trophies, and admiration from the crowds. A favorite with the crowds was Bob James, seen below with flagman Howdy Grant. James's family supported his weekly racing. His wife, Kitty, and children rarely missed a race. Owners and drivers held other jobs to pay the bills and support the costs of car upkeep and gasoline. Some of the greatest drivers in the sport raced at Sportsman's Park, which closed in 1956. The park reopened as a harness-racing track, which remains today.

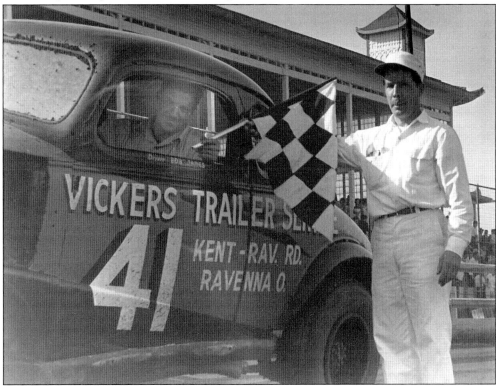

Motion pictures captured the attention of Bedford Township residents, like much of America. Itinerant projectionists traveled to small towns with projectors and reels of film. They would rent a local hall and sell tickets. The projector of one traveling projectionist was confiscated when he failed to pay for use of the opera hall in the township building. It remains on display in the Bedford Town Hall Museum. The Gem Theater, just visible in the photograph, was located in the Hains building in the early 1900s. It seated 175. Lena and Claude Stillwell purchased the Gem in 1914. Claude died four years later at age 31, but Lena continued to operate it. She later sold it and built the Bedford Theater in 1922.

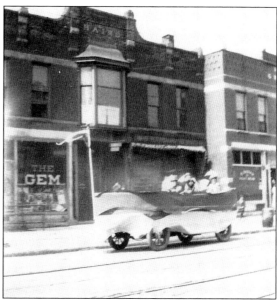

The 600-seat Bedford Theater was the first building constructed exclusively for motion pictures. It was located at 580 Broadway. There was "always a good show" at the Bedford Theater with "high class features," said its advertisements. Lena Stillwell then married Frank Yoerns, who helped operate the theater. Projectionists for Bedford-area theaters were supplied by Akron Union Local 364. In the early days, two operators were required to be in the projection booth because of the flammability of the film. When safety film became widely used in the early 1950s, the rule was changed to one projectionist. The theater was razed in 1966.

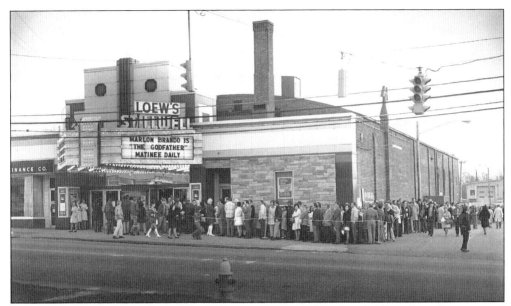

In the 1940s, Lena Stillwell Yoerns built a larger 1,000-seat theater at 310 Broadway. It was named the Stillwell after she resumed use of her name from her first marriage. Stillwell operated both theaters for several years, although she sold ownership of the Stillwell to the Fox chain in 1948. She retired in 1950. The Stillwell was razed in 1980. Many have fond memories of "Date Night" at the Stillwell, which included dinner at the Howard Johnson's restaurant across the street, and "Dish Night" on Wednesdays, when a free dish was given to patrons. (Courtesy of James Rhine.)

The Mapletown Theater at 15716 Broadway was part of a new shopping center at the southwest corner of Broadway and Libby Road. The massive lobby was a beautiful example of Art Deco design. It opened in about 1949 across the street from the Maple Heights Theater, which closed soon after. In 1985, the Mapletown was divided into a triplex where three different movies could be shown. It remained open until 2000. The building still stands. (Courtesy of James Rhine.)

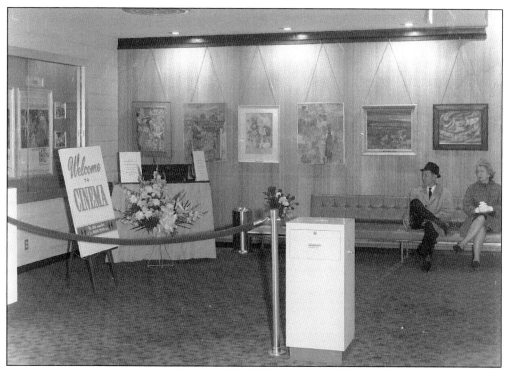

Southgate Cinema faced Northfield Road at Southgate Park Boulevard. It was part of the massive Southgate Shopping Center property considered by many to be one of the first shopping centers in modern American suburbia. The center was served by several bus lines and was very convenient for families to shop, eat, and catch a movie. The movie complex opened in 1964 and survived for several years with remodeling and added screens. It was closed and razed in the late 1990s. In the photograph, two people wait in the modern lobby. (Courtesy of James Rhine.)

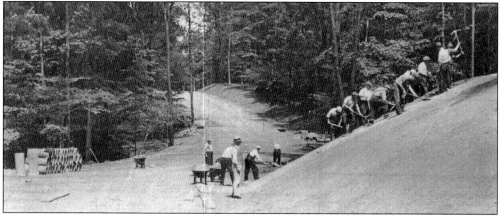

Thousands of guests visit Bedford Reservation yearly. The natural beauty of the Tinkers Creek area attracted the attention of the Cleveland Metropolitan Park District, which was purchasing acres of land surrounding the city of Cleveland. The scenic areas along Tinkers Creek were purchased from landowners to become the Bedford Reservation. Improvements to the area began in the 1930s with Works Progress Administration (WPA) employees cutting trees, grading roads, and building stone culverts for miles of trails. No longer was access limited to able-bodied hikers and horseback riders. The grainy lithograph shows the parkway being prepared for automobiles.

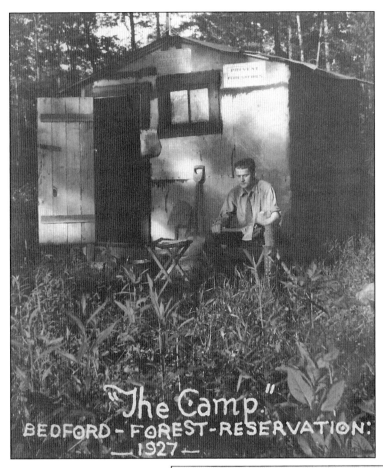

"The Camp"
BEDFORD-FOREST-RESERVATION
— 1927 —

Joseph Jesensky, a young artist and naturalist, was one of the people who recognized the biological importance of the Tinkers Creek area. In the 1920s, Jesensky lived in Cleveland and worked at the Morgan Lithograph Company. On weekends, he would ride the interurban to Bedford then hike along Egbert Road to the forests surrounding Tinkers Creek. His notes and sketches provided vital information about the area that became Bedford Reservation. In the photograph, Jesensky poses at Burnt Ridge cabin, which he built. He died in 2008 at the age of 101.

In the mid-1960s, a recreational dam known as Lake Shawnee was proposed for Bedford Reservation. The 150-acre lake was a smaller version of an earlier US Army Corps of Engineers project that would have flooded 600 acres in the gorge. William Frank Nimburger was hired by Cleveland Metroparks to survey the area. His study showed conservationists and residents that primal forest with rare species of plants and trees would be destroyed if the area was flooded. Because of his survey and subsequent public pressure, the project was abandoned.

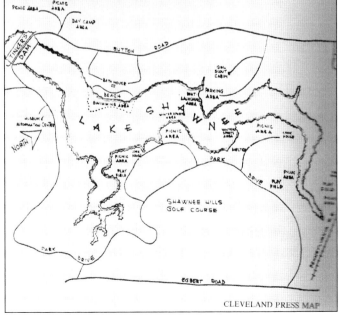

CLEVELAND PRESS MAP

Eight
NEW ROUTE OPEN

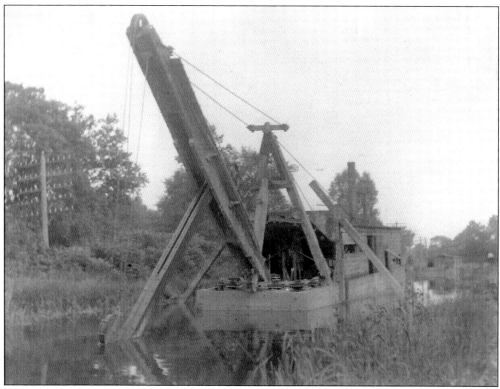

All roads in the township led to the central commercial district. From there, it was six miles down Powers Road to the Ohio Erie Canal. Powers Road is a cul-de-sac today. The dredger in the photograph is clearing sediment. The canal system provided transport for local goods to other parts of the state, but it could not compete with the railroad.

The first to lay track in the township was the Cleveland & Pittsburgh Railroad in 1852. Coming from the southeast, the line crossed over Tinkers Creek near the Great Falls on a wooden trestle then entered the village along the east side of Willis Street. In 1862, construction started for replacement of the trestle with a stone viaduct. Jacob Heinlein, of Dippold and Heinlein, was hired to build it. Heinlein wrote a journal from 1862 to 1865 in his native German. It itemized expenditures for materials and wages. Many of the workers were local residents. From April to November 1864, the railroad issued payments of $6,000 monthly. This was one of few major engineering projects during the Civil War.

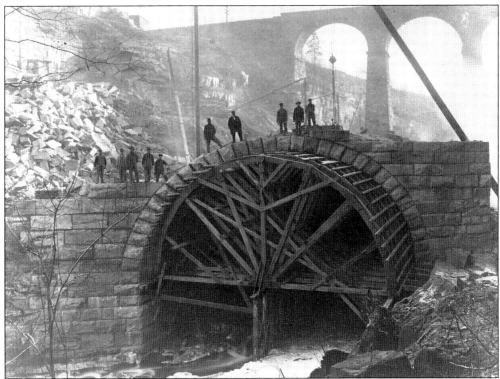

The viaduct was abandoned in 1902 when a new two-track road was constructed a few yards west. The elevation required a stone tunnel, or arch, to channel the water of Tinkers Creek. Construction began in 1900 for the arch, which is 512 feet long, 40 feet wide, and 32 feet high. The project buried the lower portion of the viaduct in fill dirt, and three additional underpasses were constructed. Today, two remain in use; both underpasses are off of Willis Street, one at Glens Road and one at the ball park road. The third underpass at Powers Road was replaced in 2002. A smaller stone arch was constructed to channel Wood Creek under the railroad right-of-way near the intersection of Broadway and Rockside Road.

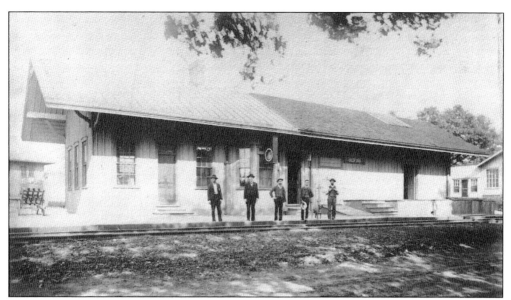

The depot for the Cleveland & Pittsburgh was located on the corner of Willis and South Park Streets. From left to right, pump operator Fremont W. Oldham, station agent Wilson T. Wheelock, telegrapher Norman McAfee, *Plain Dealer* newspaper agent William Tudor, and laborer John Kuehl pose at the station in the 1896 photograph. The old depot became a storage facility for Franklin Oil before being razed in 2006.

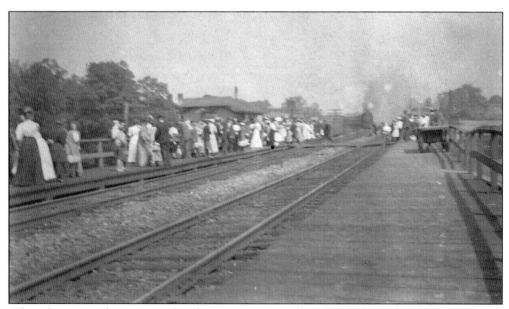

When the new tracks were completed in 1902, passengers boarded the train from a raised platform off Whitacre Court with a small shelter for waiting. A 1910 document titled *Beautiful Busy Bedford* stated, "A new Penna. passenger station is to be built the present year and will be in keeping with that company's general plans for beauty and comfort, a splendid monument in recognition of the merits of Bedford." The grand station was never built.

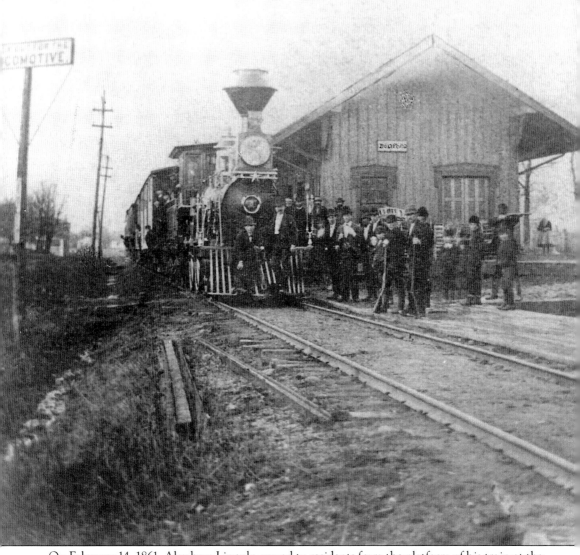

On February 14, 1861, Abraham Lincoln waved to residents from the platform of his train at the original Willis Street station. The president-elect was on his way to Washington for his inaugural. A few weeks before, Sarah Lucy Bagby stopped at the station. Bagby, an escaped slave, was captured on Payne Avenue in Cleveland and was ordered to be returned to her master. The federal marshal anticipated trouble from abolitionists and placed extra marshals on board. There were several skirmishes along the route. Bedford men were armed and ready when the train arrived. The ensuing standoff was mostly a debate about disobedience to law. If the men succeeded in freeing Bagby, they were as guilty of breaking the law as those whom they despised. The train was allowed to continue. Bagby was the last slave returned to her master under the Fugitive Slave Act. After the war, she married and eventually moved to Cleveland where she died in 1906. It is unknown if the photograph was taken when the train arrived or if it is a recreation.

The Connotton Valley Railway finished construction of a new line and depot in 1882. Advertisements listed "new routes open." There were various mergers and purchasers of the line. The Wheeling & Lake Erie purchased it in 1899. The photograph shows the station in the 1940s with Albert Balder (right), his daughter Margery Balder, and Earl Cook, the Railway Express agent. Balder was a lifelong railroad man who started work in Baltic, Ohio. In 1925, he was appointed the stationmaster in Bedford. His responsibilities included booking passengers and inspecting the boxcars and sidings in Bedford, which extended into Maple Heights. He and his staff were responsible for shipping for several Bedford companies, including Franklin Oil, Walker China, and the coal yards and the chair companies. Daughter Marjorie Balder also worked for the railroad at her father's station after graduating from college. Earl Cook's delivery area included Chagrin Falls to Brecksville. Railway Express offered package service to businesses and residences. (Courtesy of Margery Balder Thiele.)

The New York Central built track in southwest Bedford Township in 1911. The photograph shows the high trestle that spanned Tinkers Creek, as it neared completion. The steel structure was an attractive dare for youngsters in the area. The goal was to cross the trestle before a train came along. The New York Central merged with the Pennsylvania Railroad to form Penn Central in 1968, then Conrail in 1969, resulting in abandonment of the line. The trestle was dismantled in 1974.

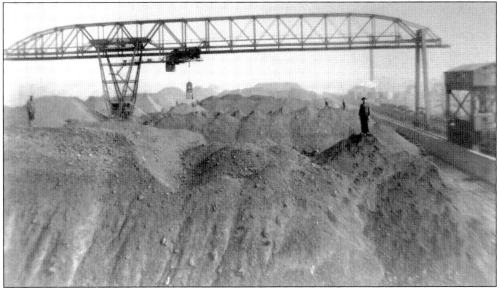

The Erie Railroad leased existing tracks of the Cleveland & Mahoning Railroad and the Atlantic & Great Western Railroad as early as 1874 in northeast Bedford Township. An important part of the route connected the ore docks on Lake Erie to the Randall Yard where ore was weighed and stored. The mountains of ore kept industries operating when shipping lanes froze in winter. Many men who worked at the Randall Yard lived in the unincorporated community of Five Points.

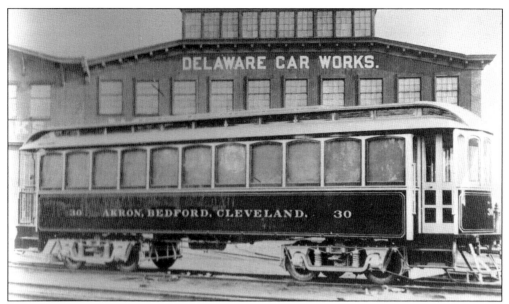

The Delaware Car Works in Wilmington, Delaware, rolls off car No. 30 for service on the Akron Bedford Cleveland Line, better known as the ABC Line. The track ran beside the Pennsylvania and Wheeling & Lake Erie Railroads as it entered the north end of the township. It turned onto Harrison Street and Broadway through town. Across from Bedford Cemetery, the line climbed a trestle to Northfield Road. The car passes by the Bedford Theater in the photograph taken in the late 1920s. The ABC changed names to the Northern Ohio Traction & Light (NOT&L) and then was renamed again to the Northern Ohio Power & Light (NOP&L). This reflected mergers with other interurban lines that allowed travelers to ride greater distances. Despite the name changes, most people continued to call it the ABC Line.

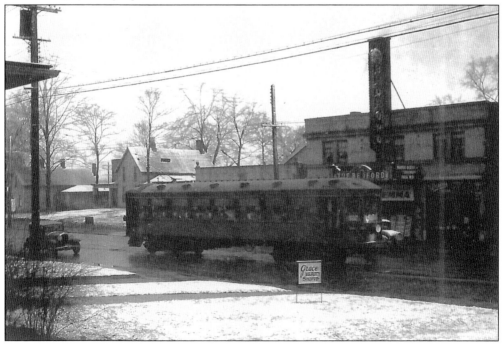

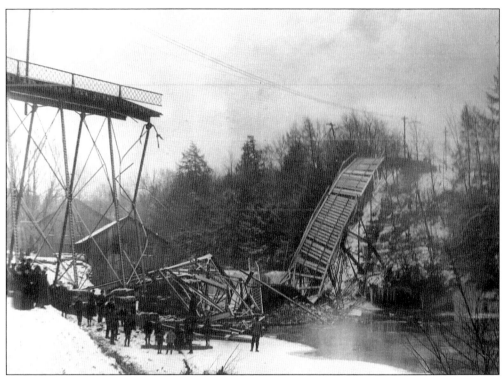

The original trestle opened for service on November 10, 1895, and collapsed two months later on January 9, 1896, at 7:45 a.m. Three trainmen were towing an empty passenger car, a coal car loaded with coal for the power station in Bedford, and a snowplow. The trestle collapsed under the load, toppling the cars into Tinkers Creek. Brakeman William Young was killed instantly. Conductor Lyman Haymaker was extricated from the entangled steel by those on the scene. Dr. L.M. Johnson and Dr. M. Golding tended him, but he died two hours later. Motorman Charles Geib survived with serious injuries. A temporary wooden trestle was erected immediately, and a stronger steel trestle was built within 35 days of the accident. It served until the end of the interurban era in 1932. The power plant building is at 994 Broadway.

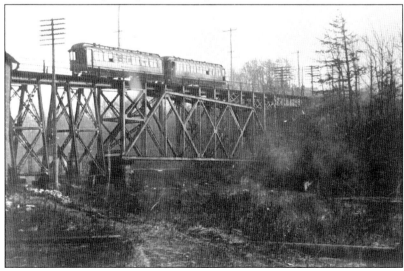

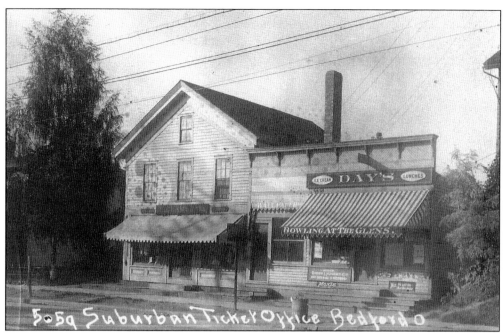

From the first trip in November 1895 to the last run in March 1932, passengers traveled in relative comfort. Stops were numbered; Stop 10 was the Dunham Bridge in Maple Heights, Stop 11 was near the Jack & Heintz plant, Stop 18 was Glendale Avenue, Stop 19 was Grace Street, Stop 20 was Columbus Road, and Stop 21 was Bedford Public Square near Day's Confectionary, which served as a ticket office. Passengers could buy sundries while waiting. Their advertisements read, "Those milk drinks are great at Walter Day's Confectionary."

Dominic Flask was a trackwalker for the interurban line along the Bedford right-of-way. He poses with his young son Tony at the family home on Broadway between Glendale and Magnolia Streets. Trackwalkers had responsibility for the safety of a section of track. Their daily inspection included examining the rails, joints, and ties and looking for potential hazards. Several generations of Flasks have lived near the Broadway and Glendale Street intersection.

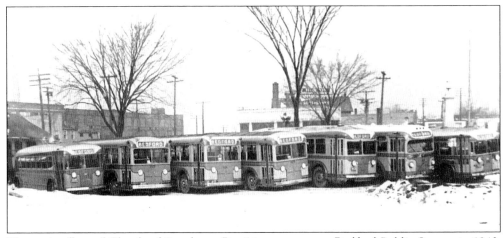

The entire fleet of Cleveland Southeast Bus Line appears on Bedford Public Square in 1940. Originally named the South End Motorcoach Company, the line was founded by Tony and Louis Walters and Clem Raimer in the early 1930s. It supplied transportation for Bedford-area residents when the interurban system closed in 1932. In 1947, the company moved to a new terminal on Harrison Street. Architects Copper, Wade, and Peck designed the one-story block building featuring a unique curved-glass wall. After a fire in the service area that destroyed the garage and seven buses in 1964, the building was rebuilt and enlarged. The unique architectural features of the 1947 portion remain.

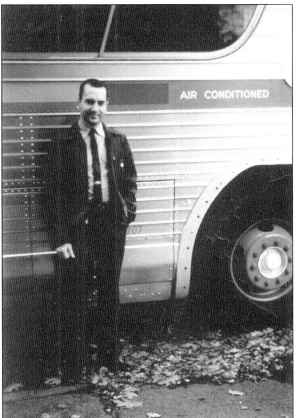

Don Sazima worked for the company for more than 40 years. He remembered the excitement at the end of World War II when residents packed buses to celebrate on Cleveland Public Square. He recalled two other lines in Bedford Township. Geauga Lake Transit served eastern Bedford Township. The other was a loop bus called the Northfield Bullet, which ran from Northfield in Summit County. Sazima recalled riding the Bullet outbound to swim at Fell Lake. The route of the Northfield Bullet included the slight grade up Columbus Road in Bedford. The bus went so slowly that many young bike riders enjoyed beating it to the top of the hill. (Courtesy of Ruth Sazima and family.)

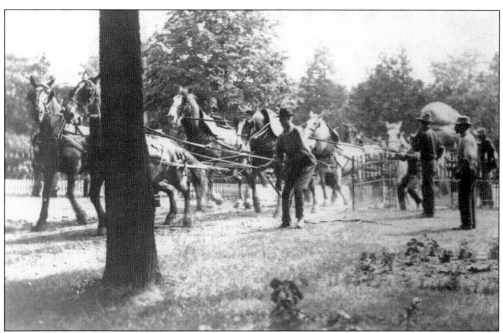

In an earlier time, teamsters hauled with wagons and horses. The 1904 photograph shows the Gleeson family stone being moved into Bedford Cemetery. The stone was unearthed during the construction of the ABC Line at Stop 7 north of the township line. The six-foot-tall, nine-and-a-half-foot-wide boulder weighed 21.5 tons. It took four two-horse teams to pull the load. Fred Vollins was the teamster in charge. Robert Hamilton poses beside a new truck for the fleet of Hamilton Trucking Company in the 1947 photograph. Hamilton's father, Donald, started the local business in 1933. Donald Hamilton was born in Marietta, Ohio, and moved to Bedford to work at the McMyler Interstate Company. When the plant closed, Hamilton started the D. Hamilton Trucking Company. (Below, courtesy of Leigh Hamilton.)

Wards Field in southern Bedford Township operated from the mid-1940s to 1955. It offered complete flight and repair service with 80-octane gasoline, a hanger, training, and taxi service. Kenneth M. Davis was the manager. Another airstrip at Miles and Richmond Roads in northeast Bedford Township was known as Bedford Miles Airport. Les Dethloff ran the private airport until 1956. He then moved to Chardon Airport in Geauga County and operated Dethloff Flying Service. The Bedford Miles Airport began life as East End Airport in 1933 according to research by Bedford Historical Society member Lynn Jones. An earlier map marks a field in the area as a US Air Mail emergency landing field.

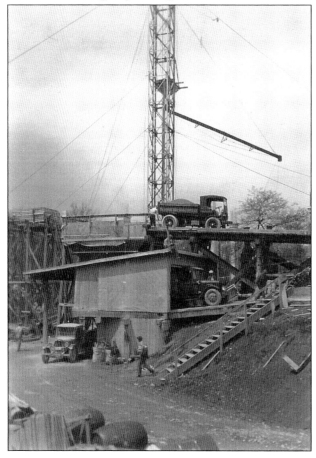

Bridges are an essential part of ground transportation. The photograph shows construction of the high-level Northfield Road bridge, which began on October 7, 1931, as part of the new state highway system. E.H. Latham, of Columbus, Ohio, was the builder with local men supplying part of the labor. It was dedicated on November 5, 1932, with Ohio governor George White in attendance. The Bedford High School band supplied the music, and student Stella Brocco was chosen to cut the ribbon. A replacement bridge was dedicated on September 12, 1987. Gov. Richard Celeste attended, and music was supplied by another generation of students in the band. Stella Brocco Bancale was again invited to cut the ribbon.

INDEX

ABC Line, 121–123
Airfields, 126
Automobile and gasoline businesses, 43–45
Bedford Glens, 108
Bedford Reservation, Cleveland Metropark, 113, 114
Bedford Theater, 111
Bell, Ralph Sr., 59
Ben Venue Laboratories, 21
B.L. Marble Chair Company, 13
Brown, Robert, 100
Charles Brown and Company Department Store, 28
Conelly, Ludwig Shaner, 65
Cowan, Mary, 61
Crestwood, 70
Didham and Small clothing company, 32
Dunham house, 48
English, Lee M., 101
Fiedler, James, 44, 100
Fitch, Benjamin Franklin, 11
Flick, Elmer, 60
Forbes Store, 28
Ford Motor Company, 22
Fountain House, 27
Franklin Oil Company, 20
Garlick, Theodatus, 52
Gates Handyside house, 56
Gem Theater, 111
Great bank robbery of 1920, 33
Great fire of 1893, 26
Ground Observer Corps, 102
Gypsies, 70
Hamilton Trucking, 125
Hensey, Andrew, 85
Hinckley's Ben Franklin Store, 36
Holmes Bronze Company, 15
Home Laundry Service, 31
Jack & Heintz Company, 23, 24
Jesensky, Joseph, 70, 114
Lee Greenhouse, 36
M&M Dairy, 34, 35
Mapletown Theater, 112
Marble and Shattuck Company, 12
McMyler Interstate Company, 13, 14
Mouat/Nienal Shoes, 32
Parsons, Tamzen, 51
Petrie Brown, Edith, 58
Samet Brothers Department Store, 32
Sedlon, Richard, 48
Southend Motor Coach Company, 124
Southgate Cinema, 113
Southgate Shopping Center, 41
Sportsman's Park, 109, 110
Stalwart Rubber Company, 16, 17
Stillwell Theater, 112
Taylor Chair Company, 11
Tibbs, Julius Caesar, 37
Walker China Company, 18, 19
Willard, Archibald M., 50
Zahn, Bert, 46

Discover Thousands of Local History Books Featuring Millions of Vintage Images

Arcadia Publishing, the leading local history publisher in the United States, is committed to making history accessible and meaningful through publishing books that celebrate and preserve the heritage of America's people and places.

Find more books like this at
www.arcadiapublishing.com

Search for your hometown history, your old stomping grounds, and even your favorite sports team.

Consistent with our mission to preserve history on a local level, this book was printed in South Carolina on American-made paper and manufactured entirely in the United States. Products carrying the accredited Forest Stewardship Council (FSC) label are printed on 100 percent FSC-certified paper.